OHIO'S INFIRMARY BUILDINGS

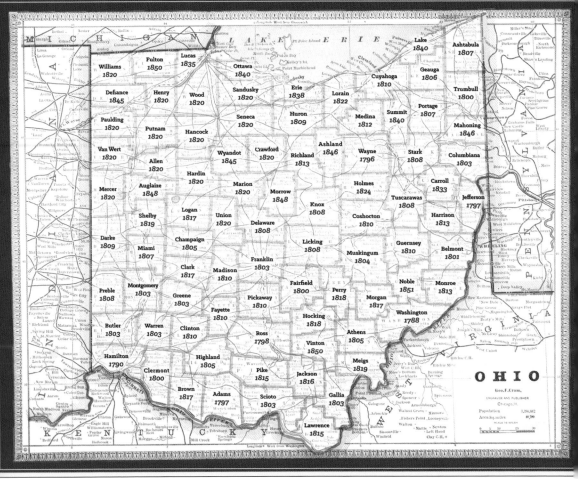

STATE OF OHIO MAP. This map shows all 88 Ohio counties and the date each county was founded. (Courtesy of Bowling Green State University [BGSU] Center for Archival Collections and Abby Bender.)

OHIO'S INFIRMARY BUILDINGS

Holly Hartlerode Kirkendall

ARCADIA
PUBLISHING

Published by Arcadia Publishing
Charleston, South Carolina

Printed in the United States of America

Library of Congress Control Number: 2023936208

For all general information, please contact Arcadia Publishing:
Telephone 843-853-2070
Fax 843-853-0044
E-mail sales@arcadiapublishing.com
For customer service and orders:
Toll-Free 1-888-313-2665

Visit us on the Internet at www.arcadiapublishing.com

This book is dedicated to all former managers and
recipients of public charity across Ohio.
And to you, TLK.

CONTENTS

ACKNOWLEDGMENTS

Collaborative efforts with organizations across Ohio made a comprehensive look at public charity possible. Opening in 2019, "For Comfort & Convenience: Public Charity in Ohio By Way of the Poor Farm" is on exhibit at the Wood County Museum in Bowling Green, Ohio, and inspired this book. Many photographs contributed for use in the exhibit were also used to produce this book and are thanked in each caption. The contributions help us remember our collective story.

On behalf of the Wood County Museum, our heartiest thanks go to photographer Jeffrey Hall for his work documenting all the former poorhouse sites in Ohio. Additional thanks go to graphic designer Abby Bender; her artistic style and vision are what give life to our museum exhibits, and I am pleased to be able to share some of her work in this publication.

Thank you to the Wood County Historical Society. Their efforts to save the former Wood County Infirmary site and corresponding records are invaluable. I would also like to thank my coworkers Kelli Kling, Mike McMaster, Marissa Muniz, and Daniel Hergert. All of what I do would not happen without the four of them.

I would especially like to thank Felicia Konrad-Bevard for her assistance in acquiring many of the historic infirmary postcards, photos, and research-related materials specific to the Farmer and Brandeberry families. Her love for the Wood County Infirmary parallels my own, and I am honored to help tell a part of her family story.

Most emphatically and with all my heart I want to thank my parents, Russell and Linda Hartlerode, for their never-ending support of my love of history and my dearly beloved late grandmother Millie Sramcik. Years ago, she told me to respect the elderly because someday I too would be old. Grandma, your words and my learning about the poorhouse system of Ohio only make me love and respect you more. Without you, I would not be the person I am today.

INTRODUCTION

A clear understanding of how public charity was distributed throughout the United States is often overlooked in history textbooks and museums alike. Even more neglected is the examination of what it meant to be poor before the introduction of modern social welfare programs. This is why it is so important that photographer Jeffrey Hall traveled over 5,000 miles across the state of Ohio to document all 88 former county infirmary sites.

When colonists first settled in the United States, local government officials began addressing the needs of the poor. Inspired by British Poor Laws, almshouses were first erected in New England, and as the population of the United States grew, many state constitutions adopted a provision for public charity relief. Ohio became a state in 1803, and it took 48 years to establish all 88 counties. On February 26, 1816, the Ohio General Assembly officially authorized boards of county commissioners to obtain farms that included housing for paupers (or the poor), and by 1874, each county in Ohio had what was originally called "the poor farm."

After the Civil War ended in 1865, there was a growing national movement toward social reform. In that same year, the American Social Science Association (ASSA) was organized in response to growing poverty, child neglect, disease, and crime. The ASSA encouraged states to establish boards of charity and as the nineteenth century drew to a close, four states—Massachusetts, Connecticut, New York, and Wisconsin—met in 1874 to discuss "state boards of charities, the care of the insane, public buildings, and pauperism"; ultimately, this group became the National Council of Charities and Corrections.

At the time of its inception in 1867, the Ohio State Board of Charities (OSBC) was primarily concerned with the construction of the main public charity building. Leaders of this advisory board agreed a "penny-wise and pound foolish" approach to funding institutions hurt both longevity of the structure and the quality of pauper care. Concentrated efforts regarding evaluation and proper management of public institutions of charity, which included infirmaries, mental asylums, prisons, schools for the blind and feebleminded, orphanages, and veteran's homes were monitored by a representative, sent to each site, to conduct inspections and make recommendations. County commissioners and boards of infirmary directors, with the input of superintendents and matrons, reviewed recommendations made by the state and worked to implement the advice of OSBC representatives. The ultimate goal was to create a uniform system of public charity distribution, as noted in the first Ohio State Board of Charities annual report, published in 1867: "Whether these public charities are dispensed directly or indirectly by the state, the provision and regulation of such charities are under its supervision, and the state is wholly responsible for their wise and economical dispensation. To meet this responsibility, two things, at least, are essential, and should be uniform: the comfort of those to whom the charities are extended and the convenience of those immediately charged with the dispensation of public charities."

Concerned with the popular perception of public charity, the very name "poor farm" was first changed in 1851 to "infirmary" and changed again in 1919 to "county home." Perception also

prompted the Ohio State Board of Charities to disband and reorganize as the Ohio Department of Public Welfare, Division of Aged. In 1928, the *Ohio Welfare Bulletin*, a publication of the Ohio Department of Public Welfare, asked the question, "What can Ohio do to modernize its county welfare system? County officials are becoming more and more conscious of the value of proper segregation of inmates and each year sees a gradual and constant improvement in the various homes across the state. There has been a movement on behalf of better hospital equipment in most of the county homes. There is no question but that the most difficult problem, which counties have to contend with, is the proper care of chronic and incurable disease." In the early 20th century, tuberculosis was a serious issue across Ohio, and a highly contagious disease among the elderly could prove disastrous. Clinton, Hamilton, Lorain, and Lucas Counties are examples of counties that built hospital structures on infirmary land to better care for those with chronic diseases.

In 1935, the *Ohio Welfare Bulletin* published a report given at the Indiana State Conference on Social Work by H.H. Shirer, former secretary of the Ohio State Board of Charities. In that report, he said, "The poorhouse is gone. Its successor will be with us for years to come despite all the new social welfare plans, but it must smell different, look decent, its inhabitants be as happy and comfortable as circumstances will permit and, at the same time, the supporting citizens (tax-payers) be satisfied with its management and willing to support it because of the good work accomplished."

The evolution of public charity in Ohio helped advisors and managers discover there was not a "one size fits all" solution for maintaining the poor. Communal farming and institutional living, while highly regimented by the Ohio State Board of Charities, were not able to adequately address the issues of each person living under county-managed public charity. Over time, able-bodied men and women that could perform the duties required for the overall upkeep of the infirmary site were outnumbered by those unable to perform daily labor. Superintendents and matrons were not trained to deal with the issues of the mentally ill. There was a concern for the moral stability of children living in infirmaries. By the end of the 19th century, counties with financial means built orphanages for children. People considered idiotic and epileptic were sent to state-run asylums. Ailments of the elderly were inhibited by inadequacies of the physical structure used for housing. For example, the OSBC recommended the old and infirm climb the fewest stairs possible. Most county infirmary buildings in Ohio were massive with multiple wings and staircases. Movement throughout the building was difficult, and full use of the structure was inefficient. In retrospect the study of public charity institutions and their shortcomings, it can be argued, led to specialized care with resources like social security, Medicare, and Medicaid to address specialized patient needs. As early as 1937, Ohio counties began tearing down infirmaries, leaving behind few photographic records and institutional documentation.

This then-and-now look at welfare relief across Ohio brings to light the necessity of public charity institutions and how the architectural remnants cultivate a lost historical narrative. Historical context is key when writing about past time periods and offers insight into social, economic, and political trends. Some of the language that appears in this body of work reflects the 19th and early-20th centuries ideas and not how people living in the 21st century might refer to modern social, economic, or political trends. The words "inmate," "insane," "colored," "idiot," or "epileptic' are not used to be inflammatory. Instead, these terms are used to show the progression of compassionate and specialized care.

One

THE WOOD COUNTY
INFIRMARY

MAP OF WOOD
COUNTY. Wood
County is divided
into 19 townships. To
qualify for relief, an
applicant was required
to live within the
county for one year.
If the applicant did
not live in the county
for one year, the legal
county of residence
was determined and
required to reimburse
the managing
county. (Courtesy
of BGSU Center for
Archival Collections.)

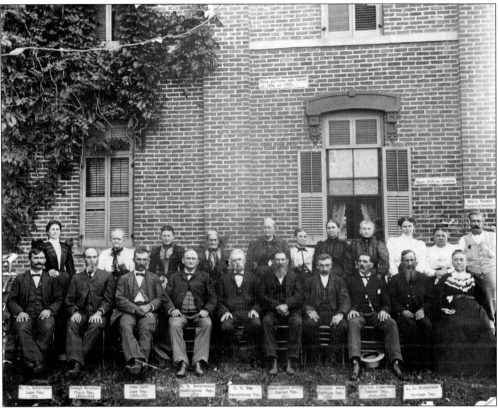

WOOD COUNTY TOWNSHIP TRUSTEES. This photograph includes Supt. Edwin Farmer and his wife, Charlotte, at an 1896 meeting with the township trustees on the grounds of the Wood County Infirmary. Township trustees were in charge of evaluating cases and awarding either temporary or permanent relief to residents applying for assistance. (Courtesy of Wood County Historical Society.)

APPLICATION FOR RELIEF. Applicants needing temporary help to pay medical bills, buy food or clothing, pay for burial, or obtain other necessities of life were given what was called outdoor relief. If an individual or family required ongoing relief considered permanent, then township trustees would discontinue outdoor relief and grant indoor relief or admission to live at the county poorhouse. (Courtesy of Wood County Historical Society.)

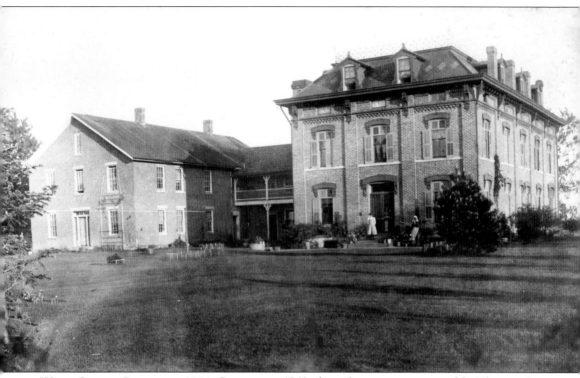

WOOD COUNTY INFIRMARY, 1885. Opening in 1869, the infirmary was managed by Thomas C. Reid until 1874, when E.M. Jenkins assumed the role of superintendent. Jenkins's position was short-lived, and in 1878 the county commissioners hired Edwin and Charlotte Farmer. Over the course of 26 years, Edwin and Charlotte raised their four children, Alfred, Warren, Lottie, and Rose, at the infirmary. In 1904, when Edwin died suddenly, their daughter Lottie and her husband, Frank Brandeberry, took over as superintendent and matron until 1949, when age and declining health forced the couple into retirement. The Farmer and Brandeberry families managed the Wood County Infirmary for 72 out of the 102 years, which is why they are the main focus of this book. Other superintendents and matrons include Dr. Charles and Ruby Petteys, 1949–1952; Gene and Mildred Roe, 1952–1969; and nursing supervisor Doris Roof, 1969–1971. This photograph of the Wood County Infirmary, circa 1885–1892, depicts the original version of the center and east wings. (Courtesy of Wood County Historical Society.)

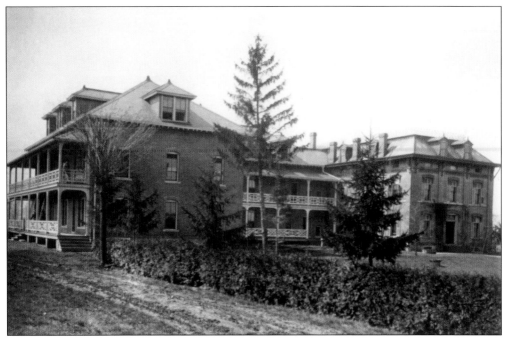

WOOD COUNTY INFIRMARY, C. 1900. The original center and east wings are depicted in the photograph found on the previous page. Considered poorly built, the Wood County commissioners hired Edward O. Fallis, architect of the Toledo State Mental Hospital, to create plans for a new center and east wings. Finished in 1898, the wings included wrap-around porches. (Courtesy of Wood County Historical Society.)

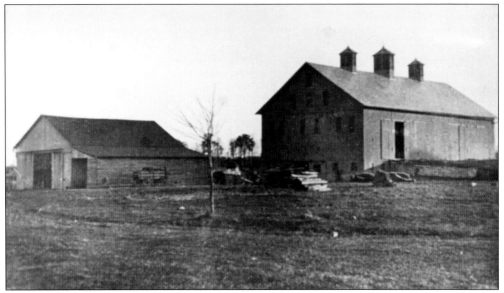

CATTLE BARN, C. 1900. On May 2, 1892, the Wood County Board of Commissioners hired S.P. Stewart to draw plans for a new cattle barn. The building contract was awarded to Brown & Hummel at a cost of $3,035, including stonework for the barn's foundation by local Mason B.F. Van Camp at a cost of $1,034, and J.Y. Haisel was paid $30 to install the brick floor. (Courtesy of Wood County Historical Society.)

CHARLOTTE AND EDWIN FARMER. Originally from England, Charlotte and Edwin Farmer judiciously cared for the sick, elderly, and mentally and physically disabled with kindness, according to the Wood County Historical Society's Institutional Archives. Edwin was the longest participating member of the Ohio State Board of Charities with 26 years of service. While Edwin maintained the farm, it was Charlotte who maintained the home. (Courtesy of Felicia Konrad-Bevard.)

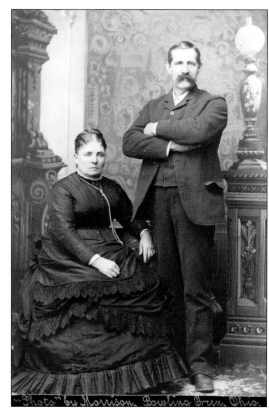

QUARTERLY BULLETIN

EDWIN FARMER.

Sketch by G. W. Harbarger, Jackson.

Edwin Farmer was born December 16, 1838, at Wantage, Berkshire, England, and during his boyhood he received the educational advantages of the community in which he lived. At the age of 20, in 1858, he came with his brother to America, and located at Millbury, in Wood County, Ohio, and engaged in the lumber business, supplying ties for the railroads and bridge timber for the wagon roads. After ten years of life as a woodsman, he returned to England, and there in 1869, he was married to Miss Charlotte Tyrell. After the death of his father, which occurred

EDWIN FARMER.*

in 1871, he returned with his wife to America. Arriving at Millbury in 1872, he resumed his former relations as partner with his brother in the lumber trade. On January 1, 1878, (nearly two years before the writer of this sketch engaged in similar work), he was appointed Superintendent of the Wood County Infirmary, which position he filled with more than honor until his death, which occurred April 11, 1904. He was, at the time of his death, the oldest Infirmary Superintendent in the State in the point of service. Only one other man, J. L. Van Duzen, of Huron County, who retired a few years ago, held a like position for a longer period.

* Engraving used by courtesy of Bowling Green Tribune.

TRIBUTE TO EDWIN FARMER, 1838–1904. After Edwin's death in 1904, the local newspaper published an article noting the continued tradition of infirmary inmates attending the Wood County Fair on behalf of county officials. For so many years, Edwin Farmer is remembered as doing little things, like paying for fair admission to help make the lives of the county charges more pleasant. (Courtesy of the Ohio History Connection.)

Frank & Anna L. Brandeberry

Frank Brandeberry

Anna L. Brandeberry

Frank B. Brandeberry and Anna, his wife, are the present efficient Superintendent and Matron of the Wood County Infirmary. They were appointed six years ago last April, and have shown themselves the right people for the place, keeping the building and farm in apple-pie order, and making things home-like for the seventy-six inmates.

Mr. Brandeberry was born in Hancock, just over the Wood county line, June 13, 1875. He was reared on the farm, and has farmed all of his life. For six years he was assistant at the infirmary under Superintendent Farmer, and March 12, 1902, married Miss Annie L., daughter of Edwin Farmer, who was born at the infirmary over which she is now the popular matron. Mr. Brandeberry is a prominent Odd Fellow and Elk, is known and liked by everybody, and is an ideal Superintendent.

FRANK AND LOTTIE BRANDEBERRY, 1904–1949. Joined in matrimony at the infirmary on March 12, 1902, their wedding announcement proclaimed the newly married couple would relocate to a farm near Miller City in Putnam County, Ohio. Fate, however, had a different plan, and the couple became superintendent and matron of the infirmary. (Courtesy of Wood County Historical Society.)

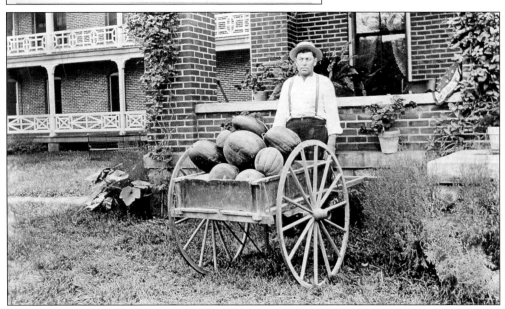

FRANK BRANDEBERRY POSTCARD, C. 1904. This postcard depicts Frank Brandeberry in the early days as superintendent. At age 17, Frank came to work at the infirmary after the death of his father, Isaac Brandeberry in 1892. The benches in the background still sit on the front lawn of the Wood County Museum. (Courtesy of Felicia Konrad-Bevard.)

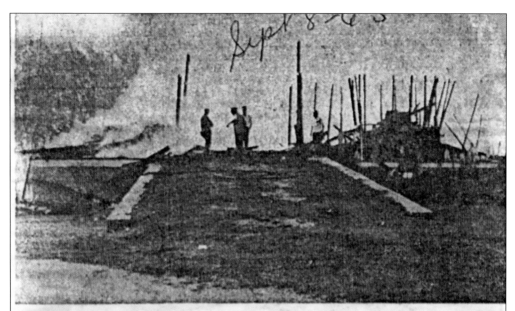

DESTROYED — Fire early today destroyed a barn at the Wood County Home located on the County Home Road, southeast of Bowling Green. The Center Township Fire Department was summoned at 12:20 a.m. and the Bowling Green department at 12:32. Firemen fought the blaze for about three hours and also watered down nearby buildings. De-stroyed in the fire were three steers, a pony, farm machinery, 2,500 bales of hay, 4,000 bales of straw and 2,500 bushels of oats. The barn was valued at $35,000, but no official estimate of the total damage was available. The cause of the blaze is unknown. (Sentinel-Tribune staff photo)

CATTLE BARN FIRE, 1965. The Wood County Infirmary farm spanned 200 acres and produced a multitude of crops until the 1950s. At one time, the cattle barn was noted as the largest barn in Wood County. Unfortunately, the cattle barn caught fire on September 8, 1965, and was destroyed. Today, only the concrete pad and part of a fence remain. (Courtesy of Wood County Historical Society.)

MAKING HAY, C. 1940s. Farming at the Wood County Infirmary by the 1940s was not managed by the residents; instead, hired farmhands cultivated 200 acres. On June 8, 1937, the Wood County Board of Commissioners approved the purchase of a John Deere Tractor and a corn cultivator for a total cost of $1,049.75. (Courtesy of Wood County Historical Society.)

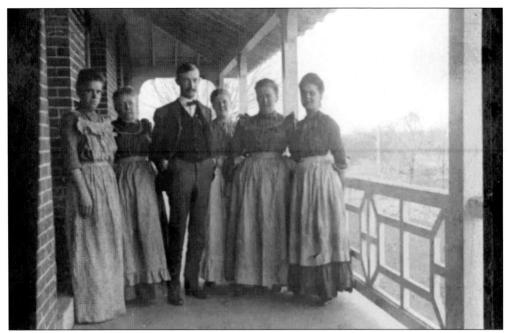

INFIRMARY STAFF, C. 1890S. Pictured from left to right are Kitty Tyrell (maternal cousin), Charlotte Farmer (matron/mother), Alfred Farmer (son of Edwin), Rose (Farmer) Zimmerman (daughter of Edwin), Lottie (Farmer) Brandeberry (daughter of Edwin/wife of Frank), and Grace (Tyrell) Zimmerman (cousin of Farmers) standing on the second floor, east wing porch. (Courtesy of Wood County Historical Society.)

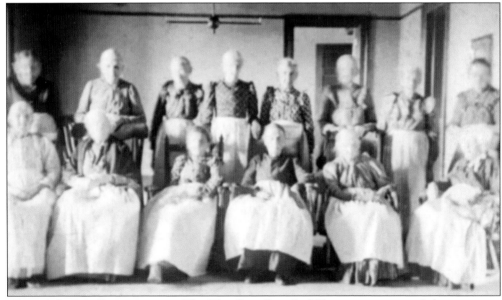

WOMEN'S SITTING ROOM, C. 1890S. The Ohio State Board of Charities recommended a separation of sexes among inmates living at infirmaries. Female residents lived on the second floor of the center wing. While the women in this photograph are not specifically identified, records held by the Wood County Historical Society indicate that several female residents lived at the infirmary for more than 30 years. (Courtesy of Wood County Historical Society.)

BERT GIFFORD, 1887–1967. Perhaps the most recognized former inmate, Bert Gifford is an iconic person in the story of the Wood County Infirmary. Born on December 5, 1887, in Freeport (now known as Wayne), Ohio, to Francis and Edward Gifford, Bert had an older brother named Harry and a younger sister named Carrie. Bert was born with a physical disability at a time when resources were not available for care. In 1918, Supt. Frank Brandeberry wrote in his journal about the day Bert arrived at the place, he would call home for the next 49 years, dying on June 20, 1967. Known to love the song "Count Your Many Blessings," Bert Gifford is remembered as a man that brought joy and cheer to employees, other inmates, and visitors alike. (Both, courtesy of Wood County Historical Society.)

INFIRMARY RESIDENTS. John Abke (left) and Jim Sprague lived and worked at the infirmary in the 1940s. Both men were not married and worked as farm laborers. Their expertise was utilized when they lived at the county infirmary, shown tending chickens in this photograph. (Courtesy of Wood County Historical Society.)

EMPLOYEE AND RESIDENT. Patricia Fergusen Roose and inmate Johnny Petroff pose in front of the stone arch of the Brandeberry Wall in 1940. Supt. Frank Brandeberry built this wall out of Fieldstone and today is a landmark characteristic of the current Wood County Museum. (Courtesy of Wood County Historical Society.)

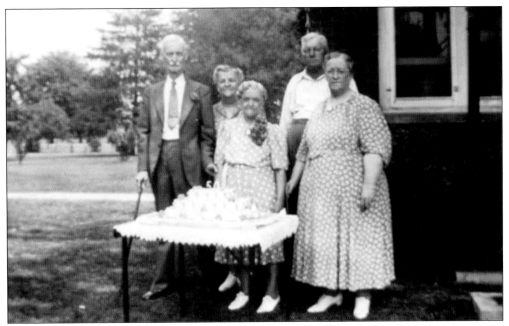

FARMER AND BRANDEBERRY FAMILY. From left to right are Alfred, Rose, Amy, Frank, and Lottie in 1942 celebrating Alfred and Amy's 50th, or golden, wedding anniversary with a family dinner and an open house for local community members at the infirmary. Amy moved into the infirmary as a resident in 1885 at age 13. In 1892, when Amy was 20 years old, she married Supt. Edwin Farmer's oldest son, Alfred. (Courtesy of Wood County Historical Society.)

ALFRED AND AMY FARMER FAMILY. From left to right are (first row, seated) Amy, Alfred, and Edwin; (second row, standing) Gertrude and Esther posing for a photograph on the front porch of the county infirmary in the early 1940s when Alfred's sister and brother-in-law Lottie and Frank Brandeberry served as superintendent and matron. After serving 16 years as a deputy sheriff for the county, Alfred was employed as the county infirmary bookkeeper. (Courtesy of Wood County Historical Society.)

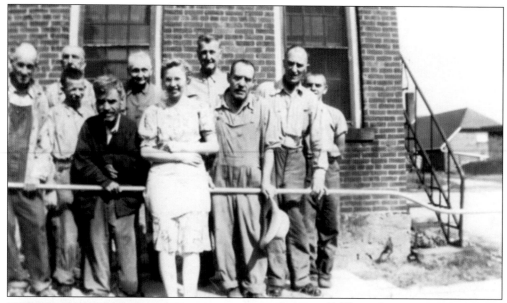

LaVerne Snyder and Inmates. Employee LaVerne Snyder and male county infirmary inmates pose on the grounds in the 1940s on the west side of the Wood County Infirmary Asylum building. Pictured from left to right are Nelson Smith, Donald Carson, Anton Martinka, Bert Gifford, John Abke, Laverne Snyder, Jim Sprague, George Huber, Benny Brust, and Johnny Petroff. (Courtesy of Wood County Historical Society.)

LaVerne Snyder. LaVerne Snyder (1920–2020) worked at the county infirmary as a housekeeper until 1946 when she married fellow Wood County Infirmary employee Harold Patten. Growing up in Portage, Ohio (just south of the county infirmary), Laverne and her husband, Harold, raised their four children in Wood County. (Courtesy of Wood County Historical Society.)

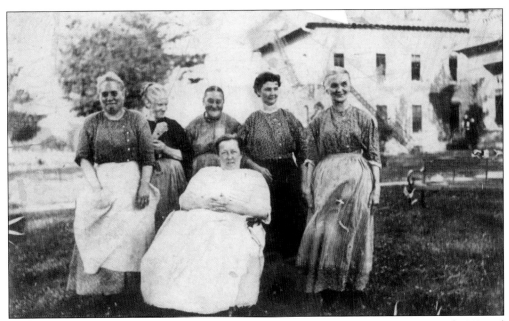

LOTTIE BRANDEBERRY ON BENCH. This postcard photograph was taken sometime around 1918 and features matron Lottie Brandeberry and five unidentified female inmates. Family folklore indicates that Lottie Brandeberry was a kind, soft-spoken individual that was well liked by staff and inmates alike. (Courtesy of Forrest Henry Jr. and Nancy Daher.)

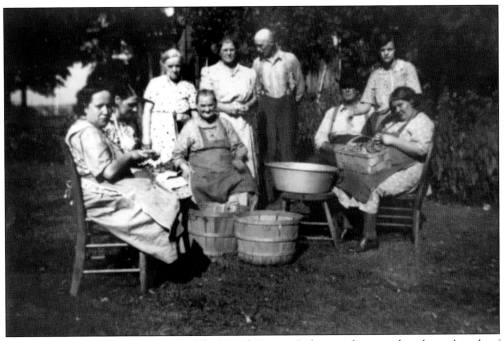

CANNING AT THE INFIRMARY, C. 1940. The Wood County Infirmary farm produced a multitude of vegetables for staff and inmate consumption. Canning was a natural part of the workday. From left to right are Dorothy Miller, Esther Bowser, Amy Farmer (staff), Alice Crusa (staff), Benny Brust, Jim Sprague, and Belle Bankey. (Courtesy of Wood County Historical Society.)

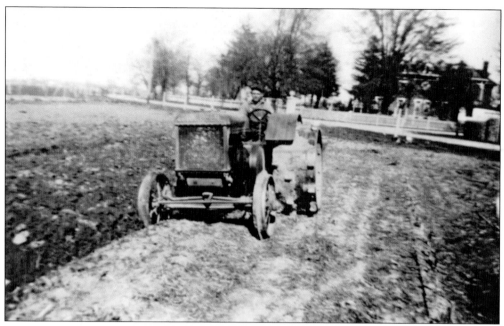

HAROLD PATTEN FARMING, c. 1940.
A native of Wood County, Harold was hired in March 1939 to assist Supt. Frank Brandeberry with the duties of the farm. A John Deere tractor was purchased on June 8, 1937, along with a corn cultivator from C.B. Kiley of North Baltimore for $1,049.75. (Courtesy of Wood County Historical Society.)

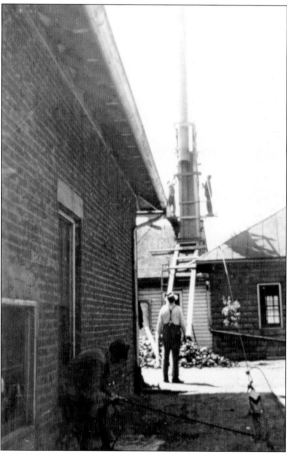

SMOKESTACK. Supt. Frank Brandeberry oversaw much of the daily operations on the ground of the county infirmary (man with back turned wearing hat). A smokestack was installed on the roof of the washhouse, or the building used to wash laundry, sometime in the early 1940s. (Courtesy of Wood County Historical Society.)

ALICE AND CHARLEY CRUSA. Records indicate that Charley Crusa began working at the infirmary in February 1922 mining ice. Both he and his wife, Alice, were faithful employees until the time Frank and Lottie Brandeberry retired in 1949. Alice and Charley thought so highly of their employers, the couple named two of their children Frank and Lottie. (Courtesy of Wood County Historical Society.)

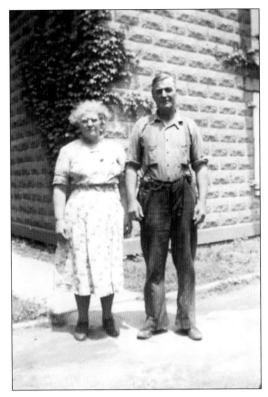

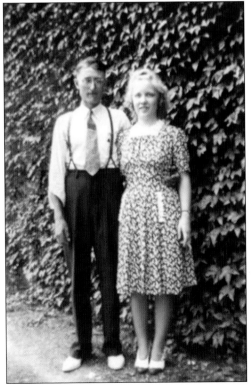

LENORE (HELBERG) AND EDWARD ESCHEDOR. It was not uncommon for extended members of the Farmer family to help with infirmary work. Granddaughter of Alfred and Amy Farmer, Lenore Helberg married local farmer Edward Eschedor in 1942. Oral history says these two met while working at the county infirmary, although there is no written proof in the records to support their official employment. (Courtesy of Wood County Historical Society.)

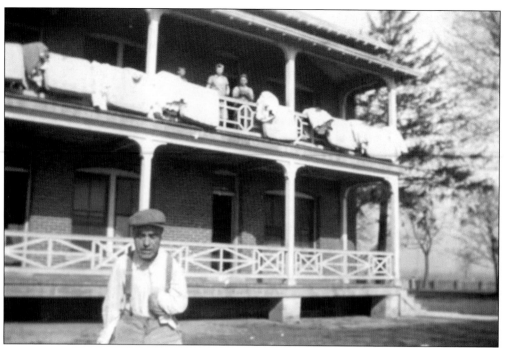

INMATES CLEANING AND THREE MEN ON THE PORCH, C. 1940S. The wrap-around porches featured on the center and east wings of the county infirmary are defining structural characteristics. Today, evidence of people milling about on those very porches is evident by the inscriptions inscribed on the bricks. Infirmary inmates, from left to right, Donald Carson, Evelyn Lehmann, and Johnny Petroff pose while airing out mattresses on the second floor of the east-wing porch, while fellow inmate Bert Gifford stands in the foreground. In the image below, while standing on the first-floor center-wing porch, from left to right, Donald Carson, George Mathias, and an unidentified man socialize. Wear and tear on the porches prompted a complete rebuilding and restoration and, in 2010, the Wood County Historical Society rededicated these iconic architectural pieces. (Both, courtesy of Wood County Historical Society.)

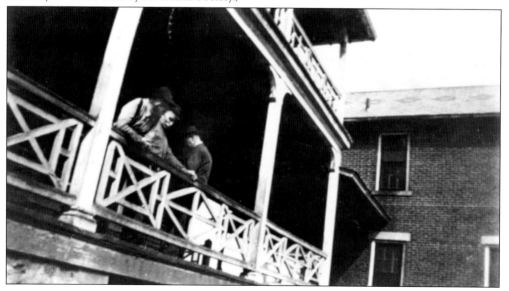

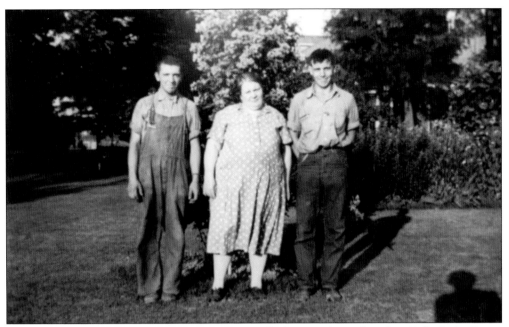

EARL, BELLE, AND LOUIE BANKEY, C. 1940. Originally from Luckey, Ohio, Sara Belle Staler Doutt was the mother of six children. Belle lived at the infirmary from 1940 to 1943 with her sons Earl and Louie. Earl was readmitted in 1951 and lived at the infirmary until his death in 1975. Earl, Belle, and Louie are pictured here from left to right. (Courtesy of Wood County Historical Society.)

LAUNDRY DAY. In 1910, the Wood County commissioners paid $1,048.50 for a laundry building. Water to wash clothes was pumped from the onsite reservoir, and it was not until the 1950s that the site was connected to the city water supply. Line drying was the one constant throughout the life of the infirmary, and the clothes poles remain on the present-day museum site. (Courtesy of Wood County Historical Society.)

SIDE YARD WORK. Taken from the west-wing kitchen window, this view shows Supt. Frank Brandeberry and his wife, Matron Lottie Brandeberry, working on the west side of the infirmary property. It was not uncommon for this husband-and-wife team to work right alongside the inmates they managed. In a report submitted in 1943 by the Division of Aged under the Ohio Department of Public Welfare, it was noted that "the Superintendent and his wife cannot be criticized too much as their great troubles is a shortage of necessary help and personnel." By the time this photograph was taken in the 1940s, Frank and Lottie Brandeberry had been in charge for over 35 years. (Both, courtesy of Wood County Historical Society.)

ESTHER BOWSER. Arriving at the infirmary on August 19, 1937, at 25 years old, Esther Bowser was a resident for 27 years, dying at age 51 on May 18, 1964. Born in Lucas County, Ohio, Esther moved to Grand Rapids, Ohio, in Wood County to live with relatives John & Ada Painter in the 1930s before coming to the infirmary. (Courtesy of Wood County Historical Society.)

GEORGE HUBER. Born December 25, 1898, in Portage, Ohio, George Huber came to the infirmary on November 19, 1919. By May 30, 1921, George's brother John joined him. According to World War I draft cards, both George and John were feebleminded. George died at the infirmary in 1944 at age 46, while his brother John lived at the infirmary until his death in 1976. (Courtesy of Wood County Historical Society.)

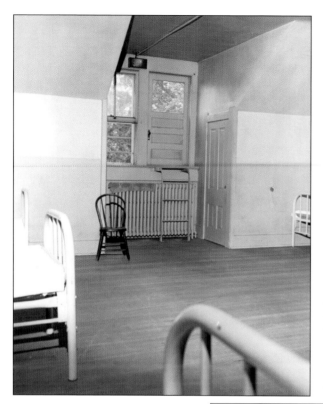

ATTIC DORM AND CENTER WING STAIRS. In 1879, the Ohio State Board of Charities wrote about the construction and upkeep of infirmary buildings. It was suggested infirmaries be constructed for durability and not for show. Attics should be used as overflow dormitory space and only accessed for sleeping. Interestingly, the Ohio State Board of Charities also recognized the populations living in infirmaries were made up of the elderly, disabled, and sick people and should climb the fewest stairs possible. Throughout the state of Ohio, infirmaries were massive multistory buildings. The Wood County Infirmary building is just one example of an infirmary containing three separate staircases with access to four floors. (Both, courtesy of Wood County Historical Society.)

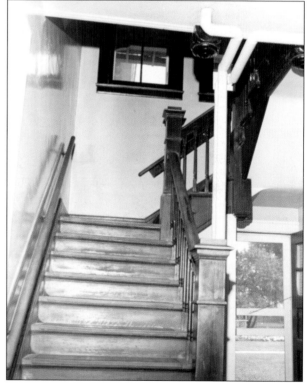

ATTIC BATHROOM AND DRINKING FOUNTAIN. The ability to locate water on the infirmary grounds proved difficult, and in 1886 and again in 1942 water reservoirs were constructed. A cistern, or a tank to hold water, was installed on the northern side of the property. When the water froze in the winter, hired men and able-bodied inmates would cut chunks of frozen water out of the reservoirs and place the ice in the cold storage building. It was not until the 1950s that the infirmary was hooked up to city water. Previously, inmates had access to two privies for their bathroom needs. The lack of suitable indoor plumbing was one of the reasons local community members petitioned for the construction of a new nursing home building for the comfort and convenience of county home residents. (Both, courtesy of Wood County Historical Society.)

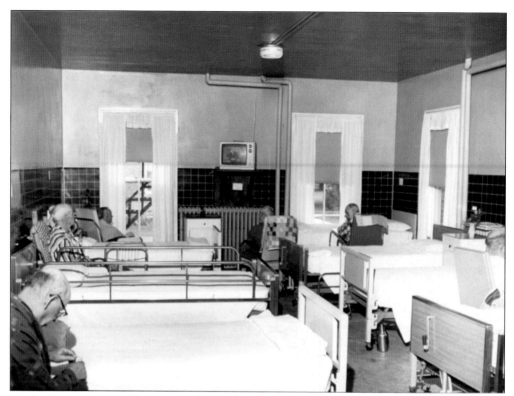

MEN'S WARD, C. 1960S. The functionality of the infirmary transitioned from public charity building to a home for elderly patients with limited financial means. The Ohio Department of Public Welfare recommended tearing down infirmary buildings and constructing hospitals for the elderly as early as the 1930s. In 1971, infirmary residents moved across the street to a modern nursing home facility known as Woodhaven. (Courtesy of Wood County Historical Society.)

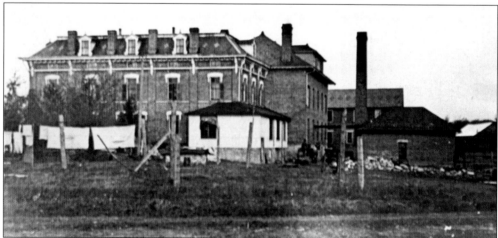

WOOD COUNTY INFIRMARY, C. 1900. This side view of the county infirmary shows what the site looked like before the construction of the icehouse in 1905 at a cost of $3,634, using repurposed bricks from the second Wood County Jail. Today, all chimneys have been removed from the east and center wings, and the smokestack was removed from the washhouse. (Both, courtesy of Wood County Historical Society.)

Two

INFIRMARIES OF

NORTHWEST OHIO

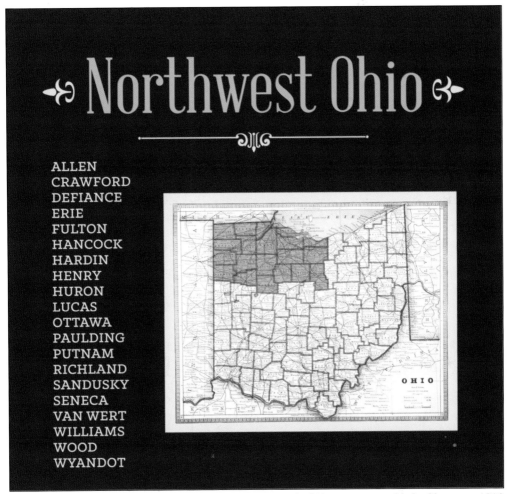

Northwest Ohio

ALLEN
CRAWFORD
DEFIANCE
ERIE
FULTON
HANCOCK
HARDIN
HENRY
HURON
LUCAS
OTTAWA
PAULDING
PUTNAM
RICHLAND
SANDUSKY
SENECA
VAN WERT
WILLIAMS
WOOD
WYANDOT

OHIO

MAP OF NORTHWEST OHIO. Northwest Ohio is comprised of 19 counties established between 1809 and 1850 and by 1874 each county constructed a poorhouse. Many historical photographs of former infirmary buildings from this region in Ohio exist and are on exhibit at the Wood County Museum; however, many images did not meet the qualifications for publication. (Courtesy of BGSU Center for Archival Collections and Abby Bender.)

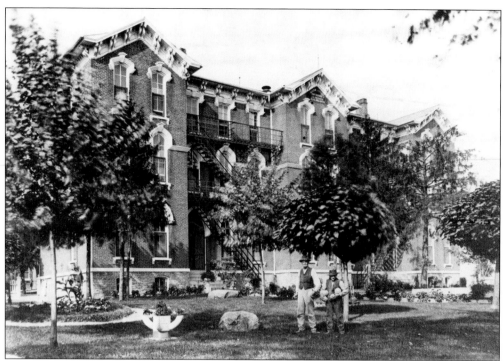

ALLEN COUNTY INFIRMARY (ABOVE) AND INFIRMARY BARN (BELOW). The three-story, 53-room brick building operated from 1859 to 1963 and was located four miles from Lima. In 1883, the farm was 320 acres with 200 acres under cultivation, a four-acre garden, and an eight-acre orchard. A 1909 Ohio State Board of Charities annual report noted that the sanitary conditions had improved and that inmates were provided with excellent food and comfortable clothing and were contented and happy. In 1963, when the original Allen County Infirmary closed, it was voted to demolish the original building. Plus Health Care Center constructed a new nursing home on the former infirmary land. This barn remains on the former infirmary site. (Above, courtesy of Allen County Museum and Historical Society; below, courtesy of Jeffrey Hall Photography.)

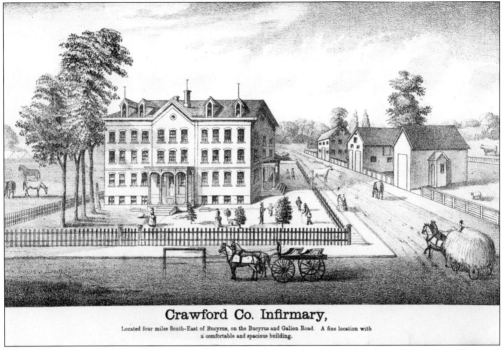

Crawford Co. Infirmary,

Located four miles South-East of Bucyrus, on the Bucyrus and Galion Road. A fine location with
a comfortable and spacious building.

CRAWFORD COUNTY INFIRMARY ATLAS ETCHING. Built in 1868, four miles from Bucyrus and located on a 293-acre farm, the infirmary was a three-story brick building with a separate dining room and kitchen occupied by the superintendent. Inmates had a separate kitchen, dining room, sitting room, and 13 bedrooms with 26 beds occupied by female inmates. Research was unable to locate a closing date and date of demolition. The calm landscape of the former Crawford County Infirmary shows little indication that a home dedicated to public charity relief ever existed. (Above, courtesy of BGSU Center for Archival Collections; below, courtesy of Jeffrey Hall Photography.)

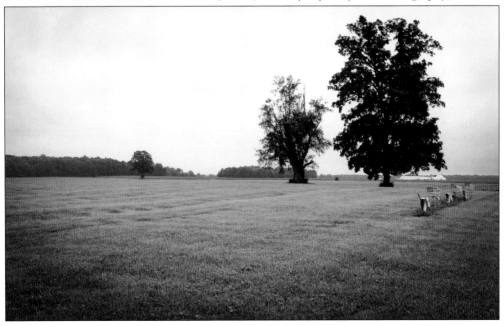

DEFIANCE COUNTY INFIRMARY. Opening in 1869, the infirmary was a two-story frame building on a farm of 230 acres with 160 under cultivation. There were 11 rooms with 5 rooms for the superintendent's family. In 1879, a two-story frame addition was built adjoining the old building containing separate dining and sitting rooms allowing for a strict classification of inmates. Originally, the insane inmates lived in a detached building with one cell. A new frame building was constructed in 1881, heated by stoves with window ventilation. It was noted that the housekeeping at the infirmary was very good. The Defiance County Infirmary, like other county infirmaries, maintained a pauper cemetery. Frequently, gravestones were numbered instead of named, making this depiction somewhat rare. Many local genealogy societies have identified inhabitants of pauper cemeteries across the state. (Courtesy of Jeffrey Hall Photography.)

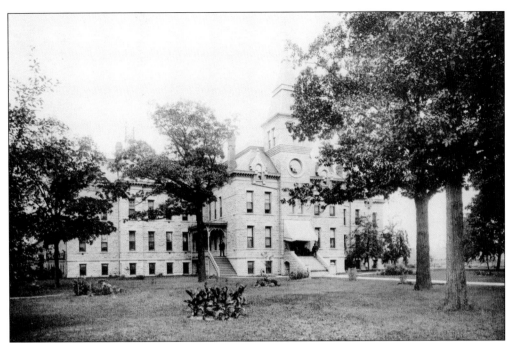

ERIE COUNTY INFIRMARY AND ADMINISTRATION BUILDING. Purchased in 1860, a two-story brick building with basement was constructed in 1863 and sat on 83 acres. The main building was expanded to three stories, with 45 rooms in all. Administration used 13 rooms including a kitchen, dining room, and 3 family rooms. Inmates enjoyed a separate kitchen, 2 dining rooms, 12 sleeping apartments, and 10 cells for the insane. After a fire in the main building, the county constructed a hospital building in 1886 out of limestone and slate. The Ohio State Board of Charities Annual Report noted the Erie County Infirmary as "bright, roomy, cheerful, and the patients are attended by a regular physician and trained nurse." This building was in operation until 1976 when the Erie County Commissioners approved construction of the Erie County Care Center, known today as The Meadows at Osborn Park. (Above, courtesy of Sandusky Library; below, courtesy of Jeffrey Hall Photography.)

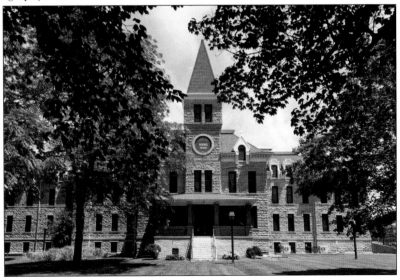

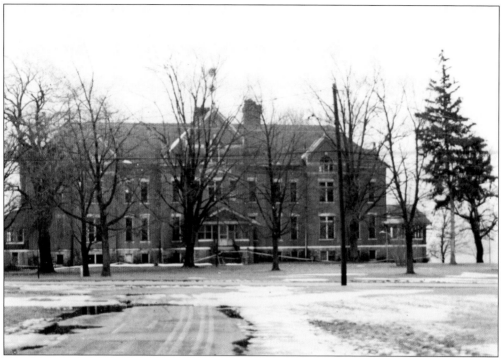

FULTON COUNTY INFIRMARY. The Fulton County Home was established in 1874 and was the last county home built in Ohio. Fulton County's superintendent and matron managed 306 acres, with 180 acres cultivated. Located four miles from Wauseon, the main building was formerly the Fulton County Courthouse and, as of 1883, contained 15 rooms. The Fulton County Infirmary was remodeled in 1894 and operated until 1975. Remaining residents of the home were transferred to Detwiler Manor. The former Fulton County Infirmary sat empty for many years until its demolition in 1992. Much debate surrounded the demolition. All that remains today are a monument and sign. (Above, courtesy of Museum and Welcome Center of Fulton County; below, courtesy of Jeffrey Hall Photography.)

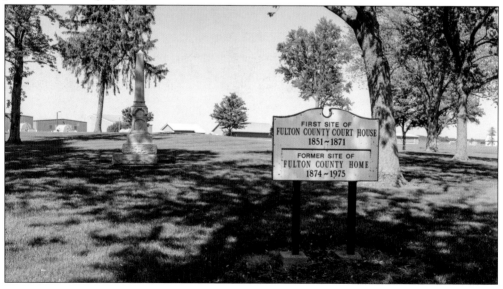

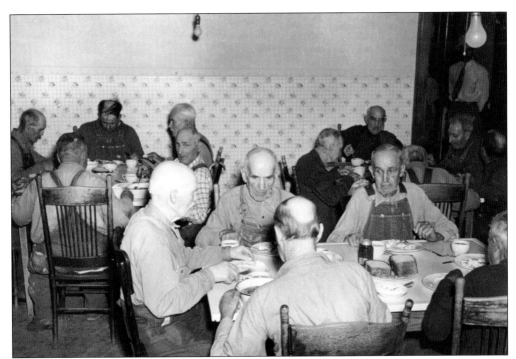

FULTON COUNTY INFIRMARY MEN'S AND WOMEN'S DINING ROOMS. The Ohio State Board of Charities recommended the complete and total separation of sexes. Each county infirmary was to have separate eating, sitting, and sleeping rooms. By the 1920s, when the Ohio State Board of Charities transitioned into the Ohio Department of Public Welfare, Division of Aged, recommendations were made that food served at county-managed homes should not be rich or fried. A hot cup of tea or bowl of hot broth before meals will stimulate appetite and aid in digestion. (Both, courtesy of Museum and Welcome Center of Fulton County.)

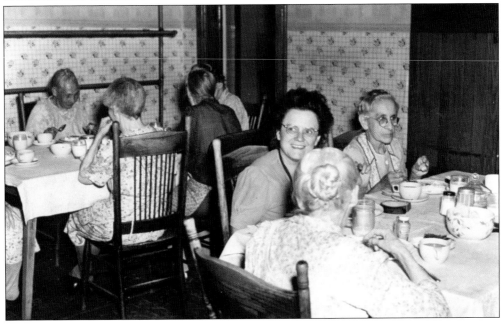

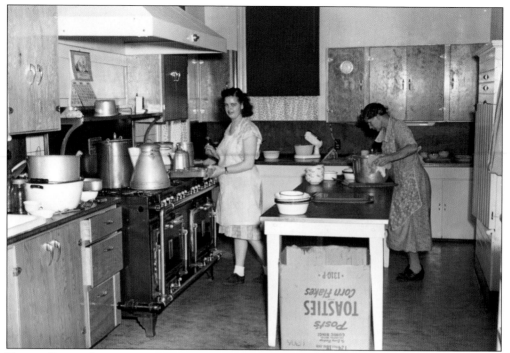

FULTON COUNTY INFIRMARY KITCHEN. It was suggested infirmary kitchens have non-absorbent floors and be equipped with a sufficient quantity of sanitary cooking utensils. The cooking range should be in excellent condition at all times. The sink and water supply should be adequate. (Courtesy of Museum and Welcome Center of Fulton County.)

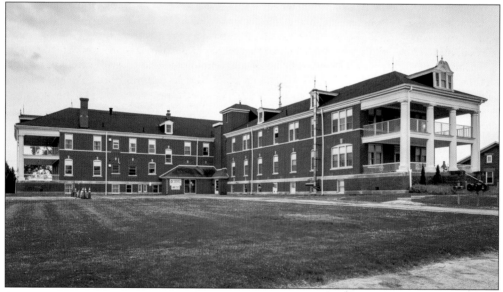

HANCOCK COUNTY INFIRMARY TODAY. Established in 1868, the Hancock County Infirmary was located 2.5 miles from Findlay. The farm was 225 acres with a single-acre cooking garden, a 5-acre orchard, and a .125-acre burial ground. The newest version of the county infirmary was constructed in 1918 and operated as the county nursing home until 1997. Today, the building is home to many county offices. (Courtesy of Jeffrey Hall Photography.)

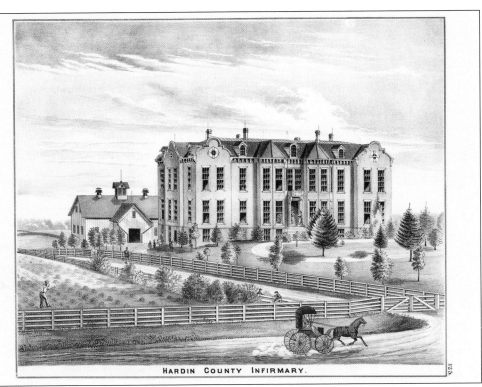

HARDIN COUNTY INFIRMARY.

HARDIN COUNTY INFIRMARY AND HARDIN HILLS HEALTH CENTER. Purchased in 1868, a 3.5-story brick structure with a basement containing 42 rooms opened in 1870 on a farm of 200 acres with 150 acres for cultivation. As noted in the 1885 Ohio State Board of Charities annual report, the Hardin County Infirmary was the first building erected in accordance with the board's recommendations and, at the same time, considered extravagant and luxurious because steam, water, and gasoline were supplied in the building. It was also noted that the superintendent and matron were intelligent and kind, and the general condition of the house and household indicates good care. The original site was in operation until 1957 when the Hardin Hills Health Center opened. (Above, courtesy of the Hardin County Historical Museums, Inc.; below, courtesy of Jeffrey Hall Photography.)

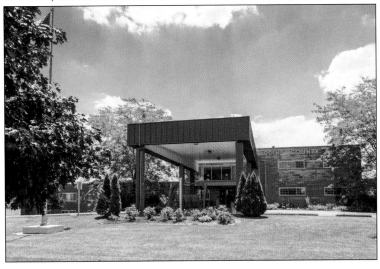

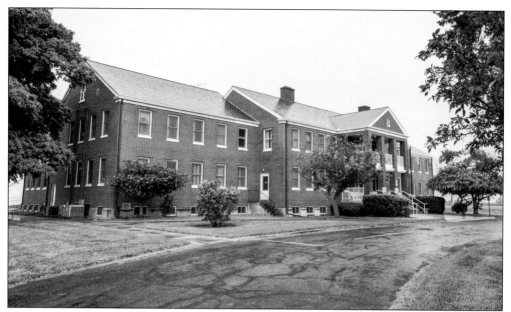

HENRY COUNTY INFIRMARY AND CEMETERY. Constructed in 1869 as a two-story brick building with 16 rooms. Insane inmates were kept in a detached building. In 1934, the original infirmary building was destroyed by fire and a new building was constructed. For the next 85 years, the Henry County Home operated as a nursing home known as Country View Haven. By the late 1980s, the nursing home was considered too old for Medicaid certification, leading to restrictions on admissions to the home. In 2019, the home closed and the building was demolished. All that remains to indicate the existence of the former county infirmary is the cemetery site. The Henry County Infirmary Cemetery uniquely features names, not numbers, adorning each stone, making identification of former inmates much easier for researchers. (Both, courtesy of Jeffrey Hall Photography.)

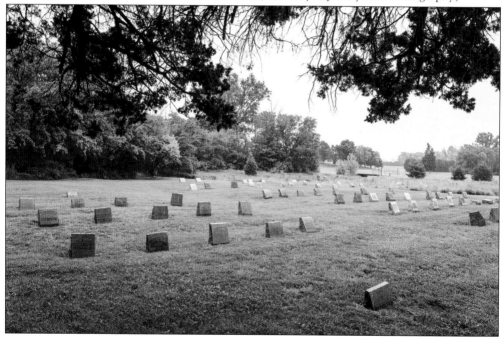

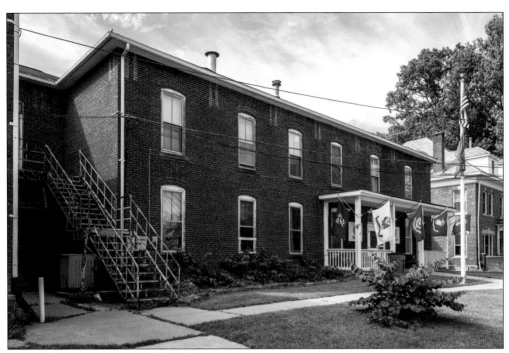

HURON COUNTY INFIRMARY. The Ohio State Board of Charities reported in 1868, "The Huron County Infirmary is a model of infirmary management. Here wise and liberal counsels upon the part of the Directors; constant attention, directed by intelligence, kindness, and skill upon the part of the Superintendent and Matron." Today, Huron County uses the former infirmary site as the Shady Lane Home. (Courtesy of Jeffrey Hall Photography.)

HURON COUNTY INFIRMARY–SHADY LANE HOME. Opening in 1848 and closing as a county-managed nursing home in 1975, the Huron County Infirmary is a little over a mile from Norwalk, Ohio. Originally operating as a farm of 202 acres, a two-story brick building was erected in the 1870s, in addition to the original two-story stone building. (Courtesy of Jeffrey Hall Photography.)

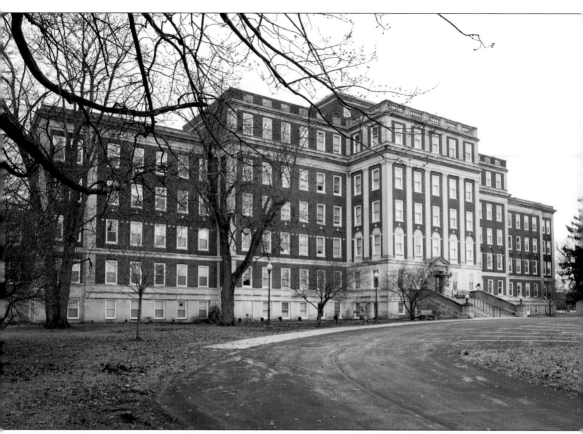

LUCAS COUNTY INFIRMARY/HOSPITAL. The Lucas County Infirmary was built in 1838 four miles from downtown Toledo. The farm contained 240 acres with a two-story main building containing 32 rooms. The site was also home to an asylum built in 1861 and, eventually, the Toledo State Mental Hospital built in 1895. As reported in the *Ohio Welfare Bulletin's Care of the Aged* report, "One of the biggest problems caring for the elderly in a county infirmary is the lack of proper and adequate hospital equipment and services for all inmates suffering from chronic disease, the ability to segregate according to intelligence and character of disease, the increasing feebleminded population, and the elimination of malignant disease." This prompted the citizens of Lucas County to pass a bond totaling $950,000 to build the Lucas County Hospital. The Lucas County Hospital closed in 1950 and is the only structure still in existence on the former site of the Lucas County Infirmary. (Courtesy of Jeffrey Hall Photography.)

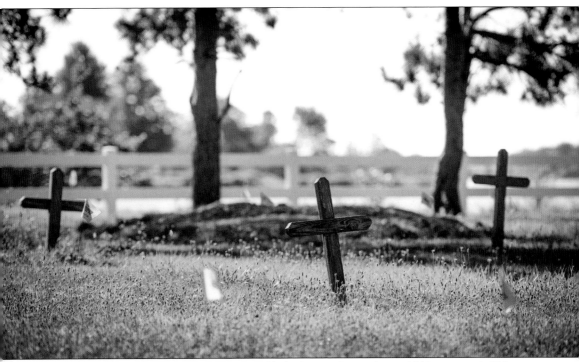

OTTAWA COUNTY INFIRMARY CEMETERY. Established in 1871 on a farm of 140 acres, with 120 acres under cultivation, the main building construction originally was a two-story brick structure with a basement. By 1885, the main building had expanded to three stories, totaling 30 rooms with 8 rooms used for administration, including a separate dining room and kitchen. Inmates enjoyed their own kitchen, dining room, sitting room, and 15 sleeping rooms. At the time of the third-floor expansion, a two-story brick-building asylum was erected for the insane inmates also including a kitchen, dining room, clothes room, and 8 small sleeping rooms on the first floor and 10 rooms with grated doors and windows on the second floor. The asylum home for those deemed insane also contained six water closets and one bathroom. Research did not pinpoint an exact year the original Ottawa County Infirmary was demolished. Additionally, the crosses featured in the photograph are not original to the cemetery. County commissioners still oversee the management of a county nursing home named the Ottawa County Riverview Healthcare Campus. (Courtesy of Jeffrey Hall Photography.)

PAULDING COUNTY INFIRMARY. Established in 1856, this farm of 160 acres originally consisted of a two-story main building containing 23 rooms with 15 beds for inmates, while insane inmates are provided for in a detached one-story frame building. According to the 1884 Ohio State Board of Charities annual report, the Paulding County Infirmary did not have any provisions if a fire were to consume the building. Unfortunately, in 1913, a fire destroyed the main building. The Paulding County commissioners contracted with the Beer Offutt Company and built a new brick structure for $17,256. (Both, courtesy of Walter Lang, John Paulding Historical Society.)

PAULDING COUNTY INFIRMARY TODAY. Located two and a half miles from Paulding Center, once the county seat, the infirmary stopped operations in 1991 and sat empty until 2002. It was at that time the Paulding County commissioners decided to sell the land and demolish all former county home buildings. (Courtesy of Jeffrey Hall Photography.)

PUTNAM COUNTY INFIRMARY-SERENITY LIVING CENTER. Originally constructed in 1868, five miles from Ottawa, the county seat, the Putnam County Infirmary was a four-story brick building containing 23 rooms. The 120-acre farm closed in 1969 and was demolished. A nursing home called Putnam Acres was established and operated until 2015, when it was sold and renamed Serenity Living Center. (Courtesy of Jeffrey Hall Photography.)

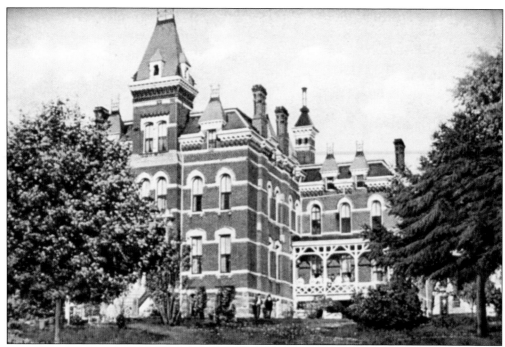

SECOND AND THIRD VERSIONS OF THE RICHLAND COUNTY INFIRMARY. Land was purchased in 1845 to establish a 160-acre farm complete with the original three-story brick building with a basement, containing 69 rooms in all. Administration used 10 rooms including a separate dining room and sitting room. A one-story brick house was available for those inmates considered insane. A fire in 1878 allowed for new construction and expanded the building to a four-story brick structure with a basement and attic. The building contained 96 rooms including bathrooms and pantries for the inmates. In 1924, the second version of the Richland County Infirmary burned down due to arson. Richland County still manages and provides nursing home care, known today as the Dayspring Assisted Living & Care Facility. (Above, courtesy of Dayspring Assisted Living & Care Facility; below, courtesy of Jeffrey Hall Photography.)

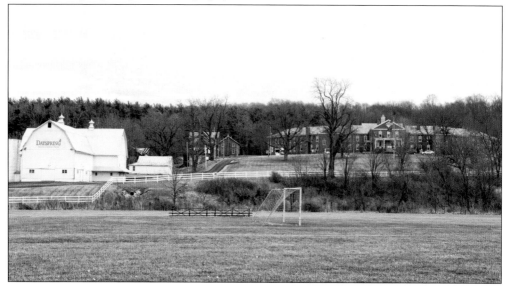

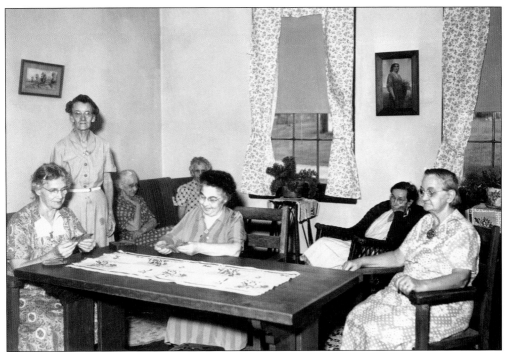

RICHLAND COUNTY INFIRMARY WOMEN'S AND MEN'S SITTING ROOMS. According to the Ohio State Board of Charities 1903 annual report, "Every infirmary should have a reading room, if possible, pleasant, well lighted room, supplied with some suitable books, religious papers, newspapers, a few magazines (even if they are old ones that can be had for the asking – better than none, where those who desired could go at any proper time and read and pass the hours pleasantly. The infirmary is neither a penal institution nor a Sunday school. These people have not come to us for reformation, they only ask for food, clothing, and shelter because they have no place else to go." It was remarked the buildings of the Richland County Infirmary showed care and the inmates respect and have confidence in the superintendent and matron. (Both, courtesy of Dayspring Assisted Living & Care Facility.)

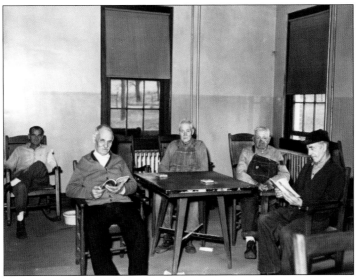

SANDUSKY COUNTY INFIRMARY. Established in 1849, the Sandusky County Infirmary was a 266-acre farm located two and a half miles outside of Fremont. A two-story frame building was erected in 1869 to accommodate 26 inmates. Renovations made in 1883 accommodated 120 inmates. At the time research was conducted for the exhibit, information about the closing and demolition of the Sandusky County Infirmary was not located. (Courtesy of Jeffrey Hall Photography.)

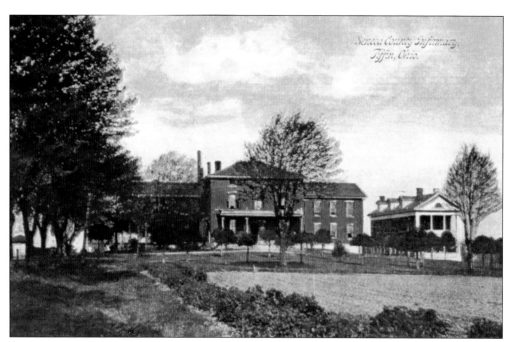

SENECA COUNTY INFIRMARY POSTCARD. Opening in 1854, this 240-acre farm was home to a three-story, 52-room, brick building with a basement. Eleven rooms are used for administrative purposes, including a separate dining room and kitchen. Inmates' apartments include a kitchen, 2 dining rooms, 2 sitting rooms, 33 sleeping rooms, and 8 cells (5 beds) for the insane. There are 58 beds for the inmates. (Courtesy of Felicia Konrad-Bevard.)

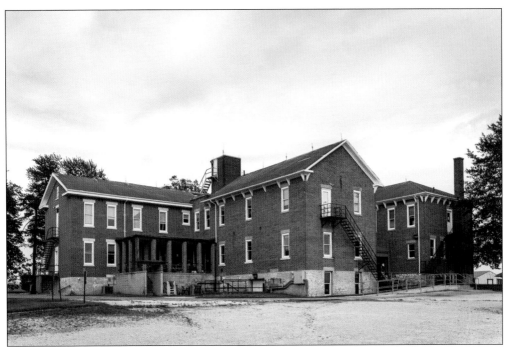

SENECA COUNTY INFIRMARY. The Seneca County Home closed in 1986 due to low rates of occupancy. While the Tiffin-Seneca Public Library holds the Seneca County Infirmary Records, 1881–1966 as part of the genealogy collection, information specifically about the history of the Seneca County Infirmary building was difficult to obtain while researching for this book. Originally, county infirmaries were under the control of county commissioners' offices, and it is assumed the land is still owned by the county. Today, the Seneca County Sheriff's offices are located on the grounds of the former infirmary. (Both, courtesy of Jeffrey Hall Photography.)

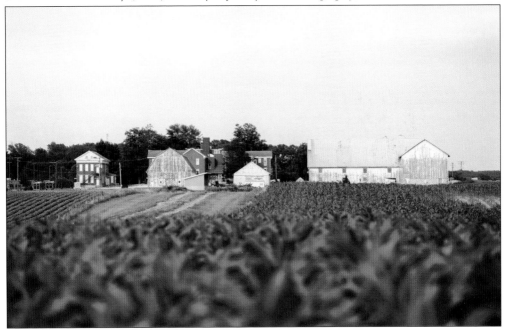

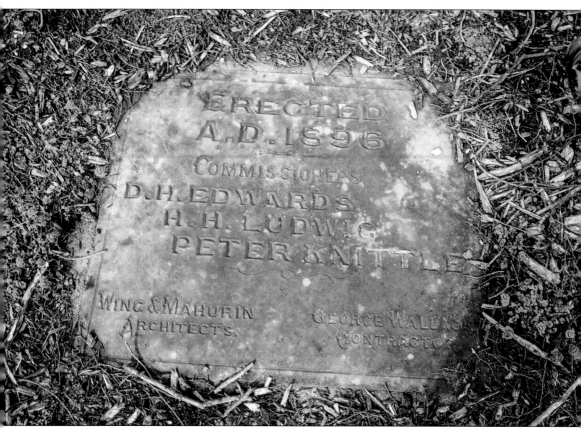

VAN WERT COUNTY INFIRMARY. Opening in 1867, the Van Wert County Infirmary was comprised of 320 acres with a 4-acre garden and a 5-acre orchard. There was a two-story brick building with 16 rooms for inmates with a west wing addition built in 1881 complete with comfortable and mostly new furniture. The Ohio State Board of Charities annual report commented on the efficiency and quality of housekeeping. Cells with grated doors and windows for the insane were also constructed. Closing in 1976, the Van Wert County Infirmary was demolished leaving only this commemorative stone noting an 1896 addition to the infirmary. Van Wert County continued caring for the elderly with the construction of the Lincolnway Home, eventually becoming the Lincolnway Behavioral Hospital. In 2012, the hospital was sold to a private investment group. (Courtesy of Jeffrey Hall Photography.)

WILLIAMS COUNTY INFIRMARY CEMETERY AND BARN. The main infirmary building was constructed in 1873 after the Williams County commissioners purchased 280 acres of land in 1871. The two-story brick building contained 24 rooms with separate dining and sitting rooms for the inmates. Those deemed insane lived in a detached frame building. Over time the infirmary grounds came to include an orchard and 35 acres of woodland. Expanding to a three-story building, the brick structure contained 23 rooms in all with 10 sleeping rooms and 27 beds for inmates. The Williams County Infirmary ceased using the old building and residents moved to the new county-managed nursing home named Hillside Country Living. In 1977, the Williams County Infirmary was demolished but several outbuildings remain. Named headstones offer a glimpse into the lives of those once living at the infirmary. (Both, courtesy of Jeffrey Hall Photography.)

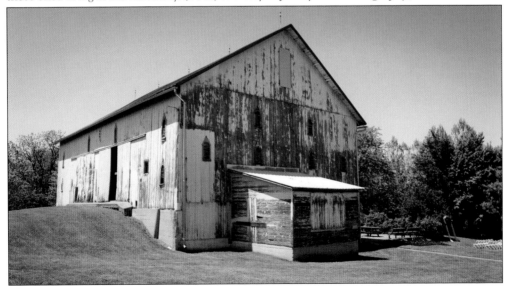

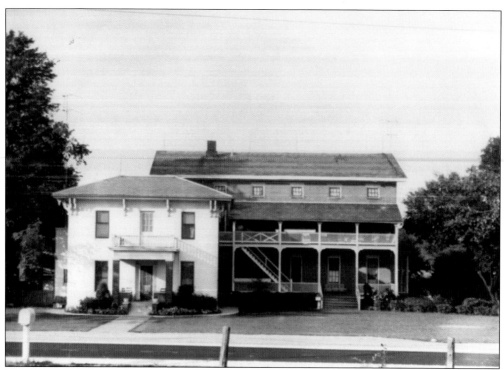

WYANDOT COUNTY INFIRMARY. Originally constructed in 1868 on a farm of 160 acres, the Wyandot County Infirmary expanded to 280 acres with 230-acres under cultivation. A 1.5-acre garden and 10-acre orchard completed the farm landscape. The main infirmary building originally was a two-story brick structure with 30 rooms, with 8 occupied by the superintendent. A four-room frame building for those considered insane was detached from the main residence. The original infirmary building was demolished in 1977, making way for the new Wyandot County Skilled Nursing & Rehabilitation Center. The barn remains as a reminder of the old infirmary site. (Above, courtesy of the Wyandot County Skilled Nursing & Rehabilitation Center; below, courtesy of Jeffrey Hall Photography.)

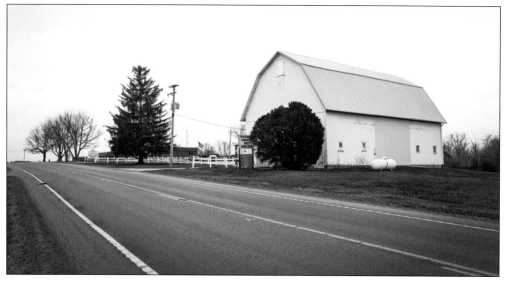

Three

INFIRMARIES OF
NORTHEAST OHIO

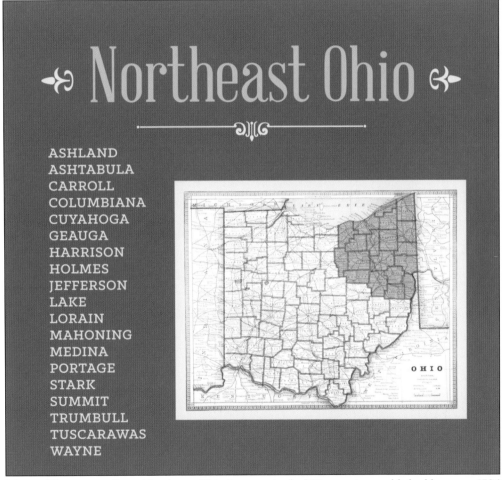

Northeast Ohio

ASHLAND
ASHTABULA
CARROLL
COLUMBIANA
CUYAHOGA
GEAUGA
HARRISON
HOLMES
JEFFERSON
LAKE
LORAIN
MAHONING
MEDINA
PORTAGE
STARK
SUMMIT
TRUMBULL
TUSCARAWAS
WAYNE

MAP OF NORTHEAST OHIO. Northeast Ohio is comprised of 19 counties established between 1796 and 1846. By 1868, each of these counties constructed an infirmary. Many historical photographs of former infirmary buildings from this region in Ohio exist and are on exhibit at the Wood County Museum, but many of the historical photographs did not meet the qualifications for publication. (Courtesy of BGSU Center for Archival Collections and Abby Bender.)

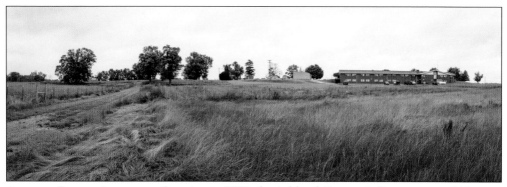

ASHLAND COUNTY INFIRMARY. Opening in 1850, the Ashland County Infirmary sat on 211 acres. The original infirmary was a four-story, 35-room building with a basement and attic. Apartments for the inmates included a kitchen, dining room, 2 sitting rooms, and 19 sleeping rooms, with 45 beds. In 1897, a more efficient brick structure was constructed for the inmates. (Courtesy of Jeffrey Hall Photography.)

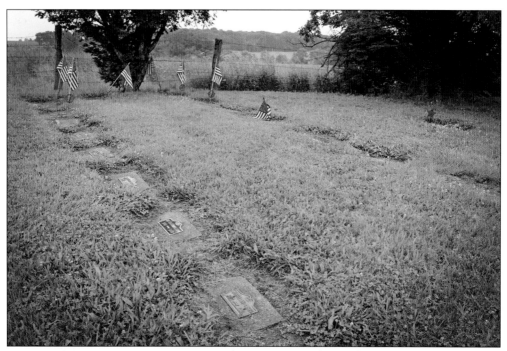

ASHLAND COUNTY INFIRMARY CEMETERY. Closing in 1975, the Ashland County Infirmary was torn down and a new facility, The Heartland Home, opened that same year on the grounds of the original infirmary. In 2009, the Ashland County commissioners decided to close the Heartland Home due to financial constraints. (Courtesy of Jeffrey Hall Photography.)

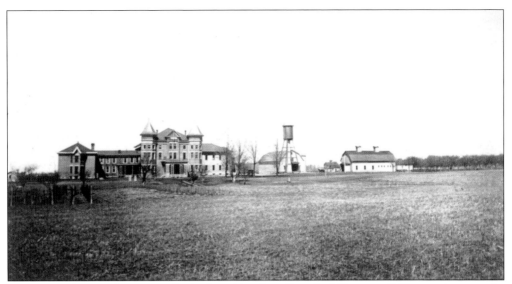

ASHTABULA COUNTY INFIRMARY. In the first Ohio State Board of Charities 1868 annual report, the Ashtabula County Infirmary is called, "a model institution. Buildings large, conveniently arranged, and entirely comfortable." A 190-acre farm was purchased in 1849, which included a four-acre garden and a four-acre orchard. It was not until 1859 when the two-story main infirmary building, made from brick, was established and contained 45 rooms. By 1909, the Ashtabula County Infirmary added a men's annex and fire protection, including a 2,500-barrel well with a tank giving 65 pounds of pressure. Unfortunately, in the 1970s, the main barn was destroyed by fire. Today, several of the outbuildings remain on the former county infirmary site. Ashtabula County continues to operate a nursing home called the Ashtabula County Nursing & Rehabilitation Center. (Both, courtesy of the Kingsville Public Library and Jeffrey Hall Photography.)

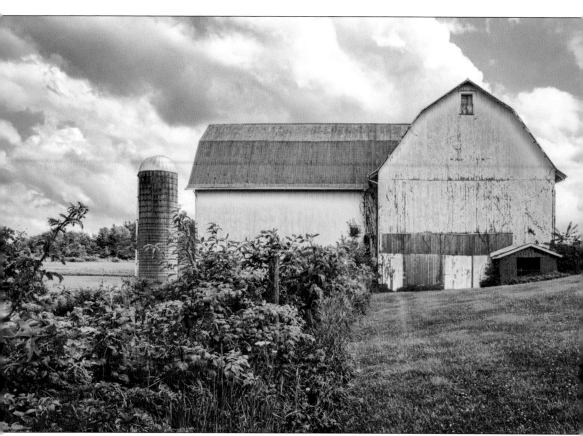

CARROLL COUNTY INFIRMARY BARN. Originating in 1837 the Carroll County Infirmary moved from Union to Washington Township and was reconstructed in 1865, 1937, and 1954. Farmland purchased in 1865 for the second Carroll County Infirmary location consisted of 346 acres with 266 acres for cultivation. Also included on the site were a garden and a six-acre orchard. The main brick and frame building was two-story with 14 rooms in all, with 7 rooms used by the superintendent. Inmates shared a kitchen, dining room, and four bedrooms in the same building as the superintendent. A two-story frame building containing eight rooms was separate from the main building and both male and female inmates occupied the home. A house for those deemed insane was also on the property. In all, there were 26 beds for inmates. A hospital building was constructed by 1937, and in 1954 the Carroll County commissioners decided to demolish the outdated buildings and construct what is known today as the Carroll Golden Age Retreat. Outbuildings of the former infirmary, like this barn, remain on the site. (Courtesy of Jeffrey Hall Photography.)

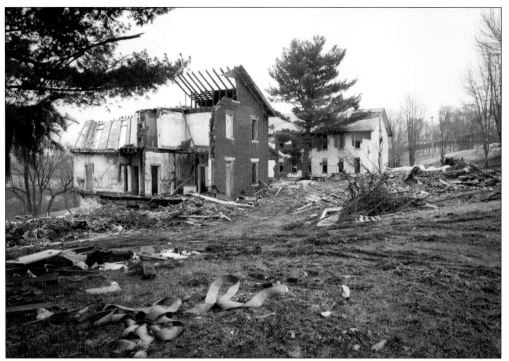

COLUMBIANA COUNTY INFIRMARY. Opening in 1829, the Columbiana County Infirmary was a farm of 332 acres with a 10-acre orchard and a 2-acre garden. The main three-story brick building included 34 sleeping rooms with beds for 75 inmates. A two-story brick building was used to house the insane inmates, and a separate 13-room administration building occupied the grounds. The Columbiana County Infirmary closed in 1977 and, in 1979, was placed in the National Register of Historic Places. Because the buildings sat vacant for many years, the Columbiana County commissioners decided, in 2017, to demolish the site. Fortunately, Jeff Hall was able to capture images of this site before the demolition was completed. (Both, courtesy of Jeffrey Hall Photography.)

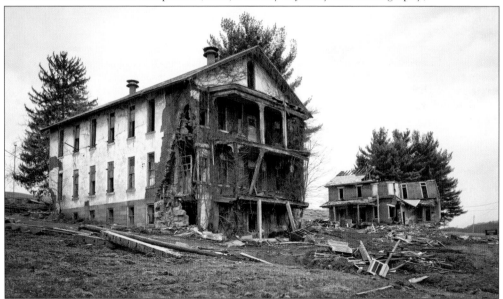

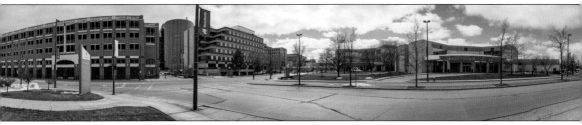

CUYAHOGA COUNTY (CLEVELAND CITY) INFIRMARY. Cuyahoga County was the only county in Ohio that did not provide an infirmary for local citizens. Instead, in 1837, the city of Cleveland constructed a hospital to maintain the poor. By 1855, poor relief was conducted at the Brooklyn Township Poor Farm, otherwise known as the city infirmary. The farm consisted of 86 acres, a 4-acre garden, and a 2-acre orchard. The main building was a brick four-story brick structure containing 73 rooms. Rooms were heated by steam, lit with gaslight, and ventilated with windows and transoms, and water was supplied by the city waterworks. Babcock fire extinguishers and alarm boxes connected the office with the city fire department. Corridors extended from the main building to an adjoining building for the insane; a three-story with 108 single bedrooms and 34 double bedrooms. There were also two hospital buildings (one for men and one for women). In all, there were 426 beds. The institution was carefully managed and kept exceedingly neat and clean. Today, Cleveland MetroHealth's campus occupies former infirmary land. (Courtesy of Jeffrey Hall Photography.)

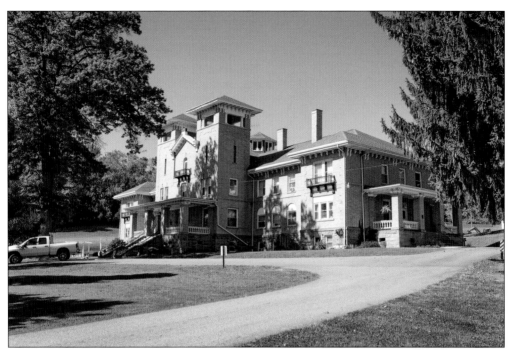

HARRISON COUNTY INFIRMARY. Initially, the Harrison County commissioners built the first county infirmary in 1845. The original main infirmary building was torn down and replaced in 1884. The 386-acre property consisted of 350 acres of tillable land, including a garden and a 10-acre orchard. The 1884 building was a three-story brick with 64 rooms including a separate kitchen, 2 dining rooms, 2 sitting rooms, and 52 bedrooms. Additionally, a two-story brick building containing 11 rooms was separate from the main building and used for the insane inmates. In 1904, a fire destroyed the 1884 version of the infirmary building. The current county infirmary building opened in 1906 and still operates as a county-managed nursing home facility. (Both, courtesy of Jeffrey Hall Photography.)

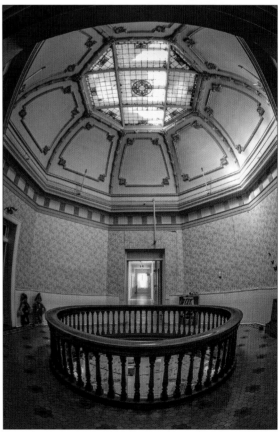

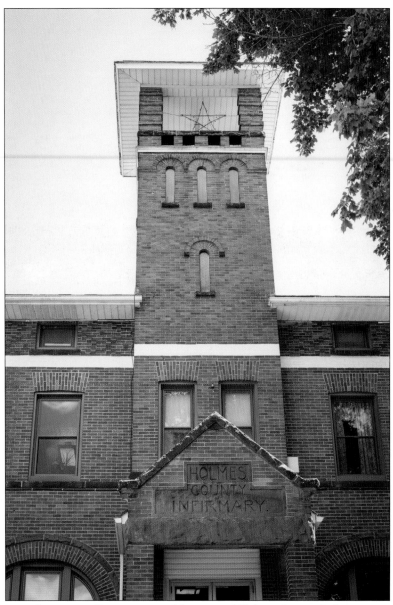

HOLMES COUNTY INFIRMARY. Construction of the original Holmes County Infirmary was completed in 1867 and burned down 28 years later in 1895, with a new infirmary-building opening in 1896. The 1867 version of the Holmes County Home was a three-story brick structure with a basement containing 52 rooms with separate kitchen and dining rooms, 2 sitting rooms, and 36 bedrooms containing 40 beds for inmates. Architects Knox & Elliott of Cleveland were awarded the contract from the Holmes County commissioners to design the third version of the infirmary building. Modeled after the block system, each "block" of the new infirmary would be for a specific function. For example, on the first floor, one block was set aside for administration purposes, connecting to other blocks for receiving visitors, a dining hall for 100 people, a kitchen, and a designated laundry space. The second-floor blocks were comprised of the superintendent's sitting room, chapel, and dormitory blocks for inmates. Today, the Holmes County Infirmary still operates as a county-managed nursing home. (Courtesy of Jeffrey Hall Photography.)

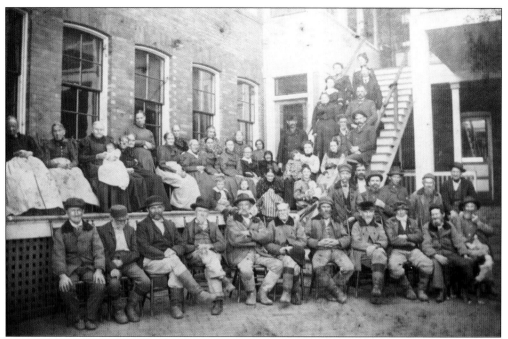

HOLMES COUNTY INFIRMARY. In 1872, Will Carleton wrote "Over the Hill to the Poor House" about an old woman whose family did not want to care for her in old age. Thirty-six years later, the Ohio State Board of Charities interviewed superintendents and matrons about how relief and services were administered in their counties for the 1908 annual report. Interestingly, some said, "Home signifies a state of mental content as well as physical comfort. The character we knew as the poor house no longer exists. It was the job of superintendent and matron to receive everything from the worthy poor, who through sickness or death of friends are forced to accept charity in their feebleness or old age, down to the lowest depths of degradation with the occasional insane, epileptic, and idiotic." (Above, courtesy of Holmes County Home; below, courtesy of Jeffrey Hall Photography.)

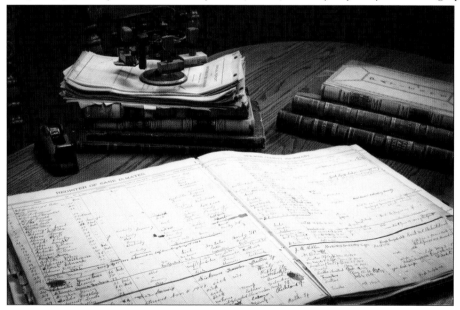

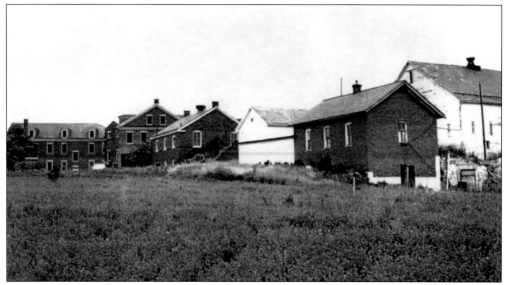

JEFFERSON COUNTY INFIRMARY. Constructed in 1824, the Jefferson County Infirmary was originally a two-story brick building with 22 rooms that sat on 160 acres. A two-story detached building with 17 rooms and 34 beds was constructed to house male inmates. In 1904, the Jefferson County commissioners constructed a new building with 73 patient rooms, including 4 dormitories, 10 bathrooms, a chapel, a kitchen, and 2 dining rooms. In 1967, it was decided to close the Jefferson County Infirmary, raze the building, and construct the Jefferson County Technical Institute. Opening in 1968 as the Jefferson County Technical Institute, this school served the local community as an institution of higher education on the grounds of the former infirmary site. In 1977, the technical institute was renamed the Jefferson Technical College. In 1995, the institute became a community college rebranding in 2009 as the Eastern Gateway Community College. (Above, courtesy of the Genealogy Department, Schiappa Library; below, courtesy of Jeffrey Hall Photography.)

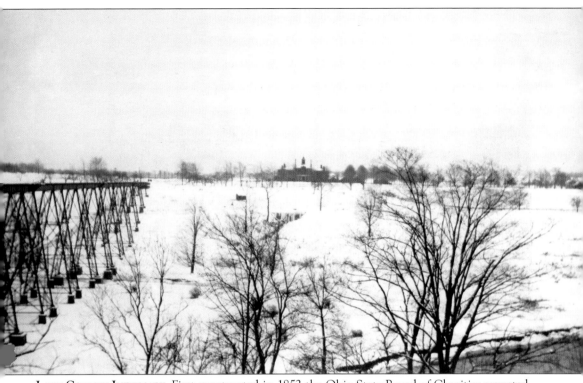

LAKE COUNTY INFIRMARY. First constructed in 1852 the Ohio State Board of Charities reported, in 1868, the Lake County Infirmary "is so homelike and presents many indications of care and comfort and thrift." A new main building was constructed in 1877 on a 40-acre farm. The three-story, brick structure contained 42 rooms. By 1885, the Lake County Infirmary farm expanded to 236 total acres including 10 acres of woodlands. The main building expanded to 100 rooms with 37 beds for inmates. It was specifically noted in the Ohio State Board of Charities 1885 annual report, the Lake County Infirmary "had excellent management and superior buildings. Probably one of the best infirmaries in the state." A 1909 report noted the addition of more rockers to the sitting room. Abundant and wholesome food seemed to make the inmates contented and happy. (Courtesy of Lake County History Center.)

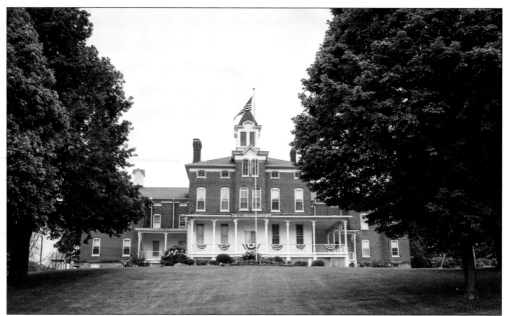

LAKE COUNTY INFIRMARY/LAKE COUNTY HISTORY CENTER. Today, the Lake County Infirmary operates as the Lake County History Center, whose mission is to preserve, educate, and learn about the history of Lake County, Ohio. When the 1877 Italianate version of the infirmary building was constructed, nine cells, located in the basement of the infirmary, were added to help manage those considered insane. The Ohio State Board of Charities was most concerned with the comfort of the inmates, including the insane, and made regular recommendations for the humane and civil treatment of infirmary residents. While it may not be apparent, cells were often used as a way to keep the insane in a safe environment until transport to a state-run mental hospital could be arranged. (Both, courtesy of Jeffrey Hall Photography.)

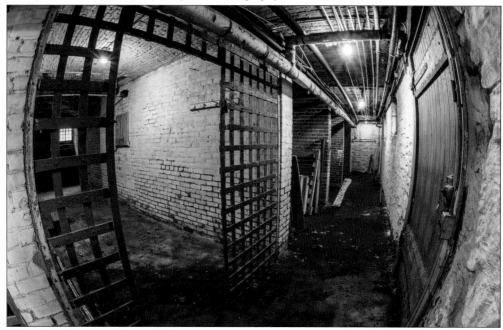

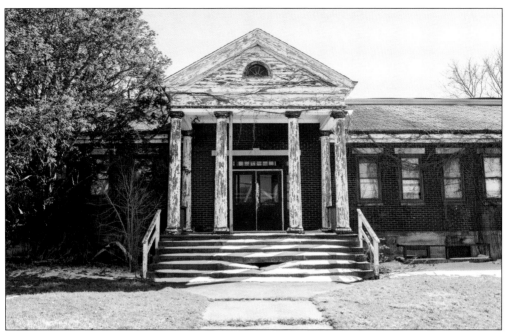

LORAIN COUNTY INFIRMARY–MEN'S HOSPITAL. Established in 1868, the Lorain County Infirmary was a 160-acre farm with a 7-acre orchard and 3-acre garden and a three-story brick building with 38 beds for inmates, including seven bathtubs. Closed in 1967, the main infirmary building was demolished in 1977. In 1931, the Lorain County commissioners opened a 48-bed facility with a large solarium, a dining room, and a kitchen for the male inmates costing $110,000 on the infirmary grounds. The Ohio State Board of Charities encouraged the strict separation of male and female inmates. Originally, the men of the Lorain County Infirmary lived in a building resembling a jail-like structure. (Both, courtesy of Jeffrey Hall Photography.)

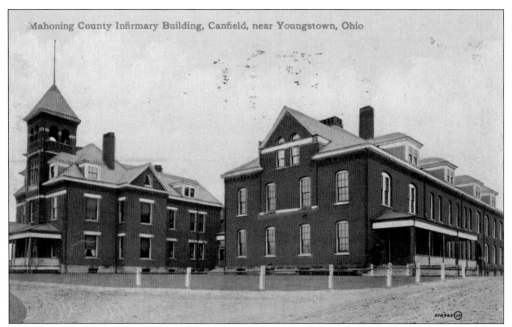

MAHONING COUNTY INFIRMARY POSTCARD. Opening in 1855, the original Mahoning County Infirmary was a 225-acre farm with a two-story brick building containing 28 rooms and a basement. By 1885, a three-story brick administration building was added for a total of 89 beds for inmates. In 1897, a fire destroyed the original infirmary building. This 1916 postcard depicts the 1898 version of the Mahoning County Infirmary. (Courtesy of the Mahoning Valley Historical Society.)

MAHONING COUNTY INFIRMARY. Closing in 1962, the Mahoning County Infirmary site was ultimately demolished. The main building endured three fires in its 107-year existence (in 1897, 1909, and 1968). When the building burned in 1897, the county commissioners rented rooms at the Park Hotel for infirmary inmates. Today, all that remains is this overgrown road and fence. (Courtesy of Jeffrey Hall Photography.)

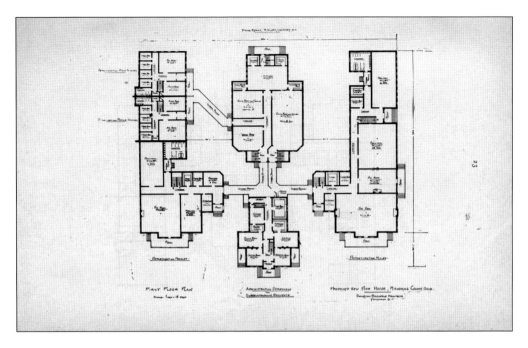

MAHONING COUNTY INFIRMARY ARCHITECTURAL DRAWING. Plans for the Mahoning County Infirmary were submitted to the Ohio State Board of Charities and met with overwhelming approval. The architectural firm of Owsley and Bouchele was hired to complete a series of three interconnected buildings to house the male and female inmates in separate departments. The administration department was located in the middle of the complex to ensure more efficient management. Additionally, a chapel building and boiler and engine room were part of the overall design. In 1909, the men's ward of the 1897 version of the infirmary was destroyed by fire. (Both, courtesy of Ohio History Connection.)

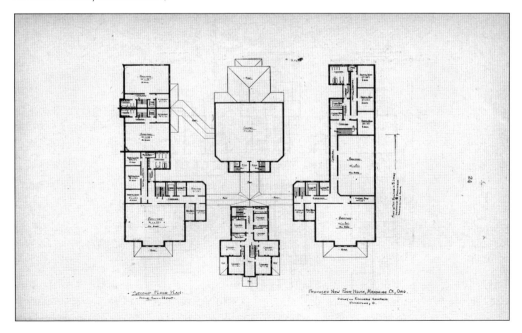

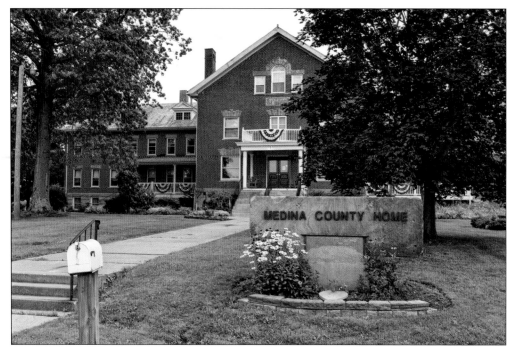

MEDINA COUNTY INFIRMARY. Constructed in 1865, the Medina County Infirmary sat on 273 acres with 195 acres of cultivated land. The main portion was a two-story brick gabled building with two attached story-and-a-half wings. The infirmary had 45 rooms with 10 used by the superintendent including a kitchen, dining room, and one bedroom. Inmates had a separate dining room, 2 sitting rooms, and 36 bedrooms with 55 beds for inmates. An additional 16 cells were available for those considered insane. The Medina County Home is still in operation as a county-managed nursing home facility. (Both, courtesy of Jeffrey Hall Photography.)

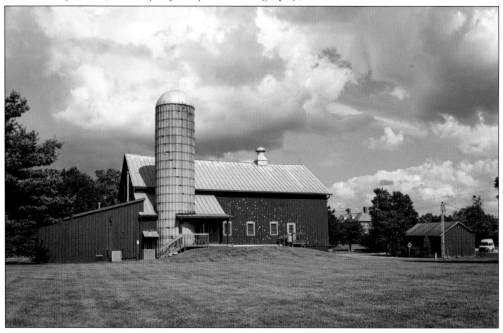

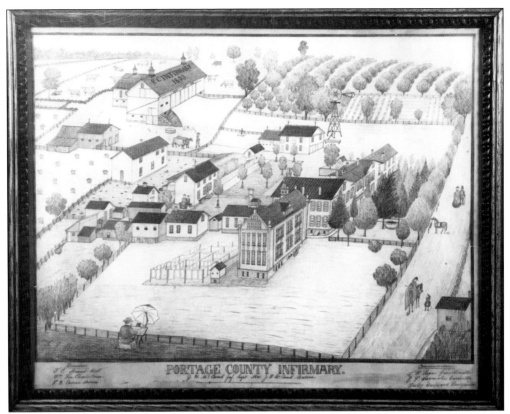

PORTAGE COUNTY INFIRMARY.

PORTAGE COUNTY INFIRMARY. A 300-acre piece of land, with 250 acres under cultivation, was purchased in 1839 for the local county paupers. It was not until 1859 that the Portage County Commissioners approved the construction of a two-story brick building with basement containing 36 rooms. Eventually, a separate two-story administration building was constructed containing nine rooms. In 1881, a fire broke out in the men's ward. The building was reconstructed and rooms were changed to secure better lighting and a comfortable hospital ward for men. The Portage County Infirmary was demolished in 1958, and today the land is home to the Portage County Sheriff's Office. (Above, courtesy of Portage County Historical Society; below, courtesy of Jeffrey Hall Photography.)

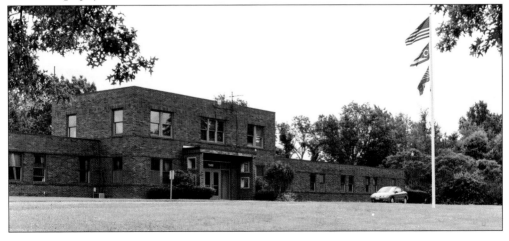

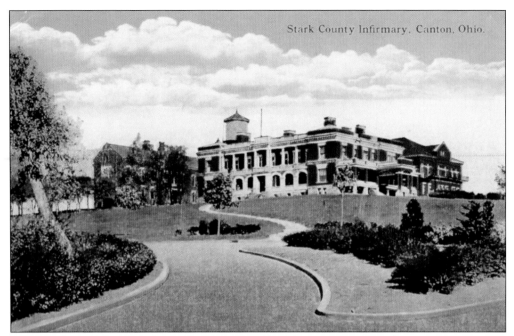

STARK COUNTY INFIRMARY POSTCARD. The original building was constructed in 1836 on a 231-acre farm with a 32-room, two-story brick building with a basement. By 1885, the building expanded to three-story with 27 bedrooms and 20 cells for the insane. The 1878 Ohio State Board of Charities annual report noted, "From cellar to attic every nook and corner is scrupulously neat and clean and a very general air of contentment pervades the household." (Courtesy of Felicia Konrad-Bevard.)

STARK COUNTY INFIRMARY/BARN AT MALONE UNIVERSITY. Research has not uncovered when the Stark County Infirmary closed, and the main building was demolished. Today, Malone University owns land the county infirmary once occupied. "The Barn," or the Malone University Student Union, is one of the most recognizable buildings on the campus. Built in 1923, the building once operated as a cattle barn for the Stark County Infirmary. (Courtesy of Jeffrey Hall Photography.)

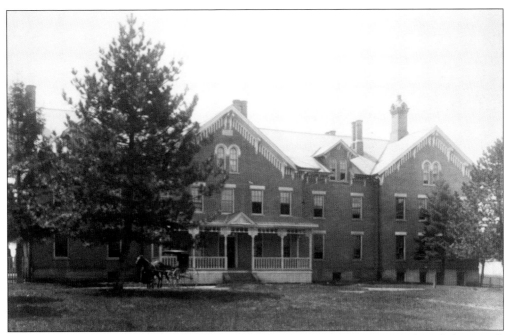

SUMMIT COUNTY INFIRMARY. The Summit County commissioners first purchased the Joseph McCune homestead in 1849 as the original Summit County Infirmary site. The farm was 236 acres and increased to 324 acres. In 1865, a new four-story building was erected, complete with a basement and 76 rooms in total. In 1919, the infirmary was moved to Munroe Falls and today is the site of the Heather Knoll Nursing and Rehabilitation Center. Operating until 1970, the Summit County Infirmary sat vacant for many years and was demolished in 1980. Dedicated in 1988, a large monument was erected for Summit County Infirmary residents buried between 1916 and 1948. (Courtesy of the Akron-Summit County Public Library and Jeffrey Hall Photography.)

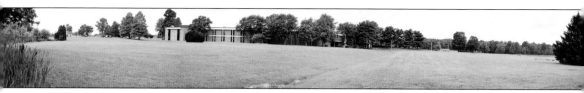

TRUMBULL COUNTY INFIRMARY. Opening in 1836, the Trumbull County Infirmary was a farm of 385 acres with 360 acres under cultivation. A two-story brick building containing eight rooms for the superintendent's family including a separate kitchen, dining room, and two family rooms. Inmates enjoyed a dining room, kitchen, 14 bedrooms, and 12 cells for the insane with 50 beds. Steam and stoves heat buildings, and a steam force pump supplied water to a tank. Management was commended for their achievements given the layout of the building. Children from Trumbull County were sent to the industrial school in Cleveland. The original county infirmary site closed in the 1960s and moved to Brookfield, becoming the Trumbull County Nursing Home. In operation until 1987, the nursing home closed, and eventually, the land was sold to Kent State University. (Courtesy of Jeffrey Hall Photography.)

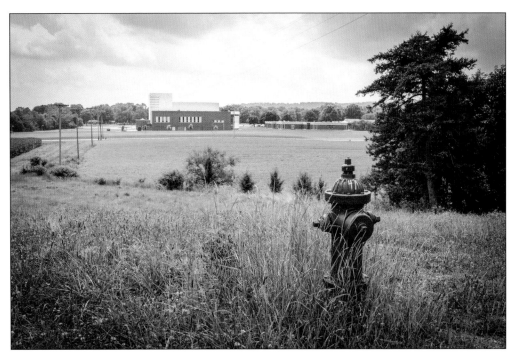

TUSCARAWAS COUNTY INFIRMARY. The original Tuscarawas County Infirmary was established in 1843 on 416 acres of farmland. A two-story brick building with 62 rooms and a basement occupied the grounds. A new building was constructed in 1929 and operated until 2009, when the Tuscarawas County commissioners decided to close the building. Kent State University Tuscarawas Campus acquired some of the former infirmary land for their campus. (Courtesy of Jeffrey Hall Photography.)

TO THE SUPERINTENDENT OF THE TUSCARAWAS COUNTY INFIRMARY:

After making the inquiry provided for by law we are of the opinion that *George Slinger* has a legal settlement in this county and is entitled to public relief. You are hereby authorized to receive the above named *George Slinger* into the County Infirmary and provide for *him* until discharged according to law.

Dated this *8* day of *Feb* 1911

Adam Maugherman
Philip Dammeck
Gottlieb W. Renner
Infirmary Directors.

TUSCARAWAS COUNTY INFIRMARY APPLICATION FOR RELIEF. This Application for Relief is for German immigrant George Slinger. According to census records, Slinger lived at the Tuscarawas County Infirmary from February 8, 1911, until his death on May 25, 1935. George is buried in the Tuscarawas County Infirmary Cemetery. (Courtesy of the Tuscarawas County Historical Society.)

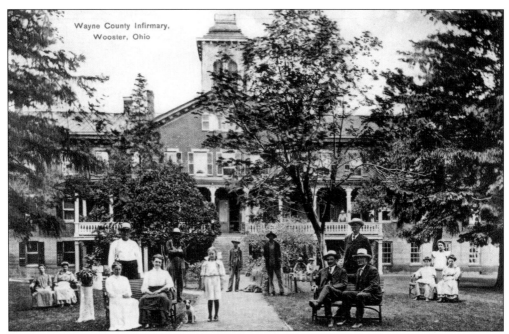

WAYNE COUNTY INFIRMARY. Two hundred ninety acres of land were purchased in 1852 with the intention of constructing a house for the poor. There were 235 acres of tillable ground. The main infirmary building was a three-story brick structure with 86 total rooms, including 13 rooms for administrative purposes. The inmates shared two kitchens, five dining rooms, three sitting rooms, a hospital room, and 32 cells for the insane. A one-story detached frame building was used as a pestilence house. The Wayne County commissioners still manage a nursing home known as the Wayne County Care Center. (Above, courtesy of the Wayne County Care Center; below, courtesy of Jeffrey Hall Photography.)

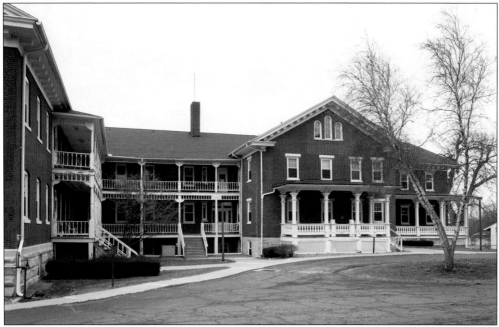

Four

INFIRMARIES OF CENTRAL OHIO

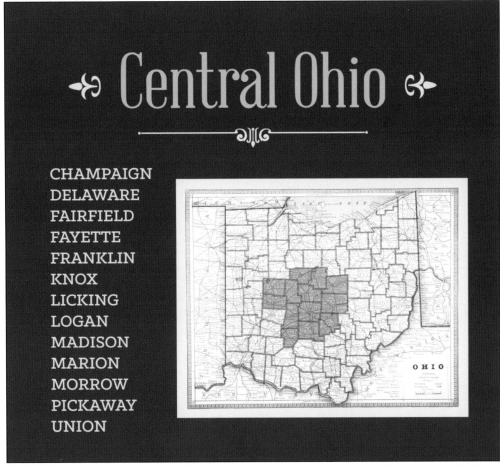

Central Ohio

CHAMPAIGN
DELAWARE
FAIRFIELD
FAYETTE
FRANKLIN
KNOX
LICKING
LOGAN
MADISON
MARION
MORROW
PICKAWAY
UNION

OHIO

MAP OF CENTRAL OHIO. Central Ohio is comprised of 13 counties established between 1800 and 1848, and by 1875, each county constructed a poorhouse. Many historical photographs of former infirmary buildings from this region in Ohio exist and are on exhibit at the Wood County Museum, but those images did not meet the qualifications for publication. (Courtesy of BGSU Center for Archival Collections and Abby Bender.)

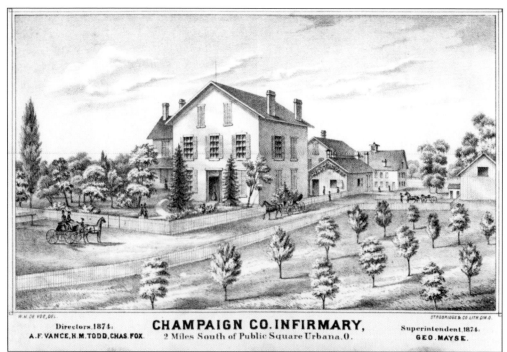

W.M DE VOE,DEL. STROBRIDGE & CO LITH.CIN.O.

Directors.1874: **CHAMPAIGN CO.INFIRMARY,** Superintendent.1874.
A.F.VANCE,H.M.TODD,CHAS.FOX. 2 Miles South of Public Square Urbana.O. GEO.MAYSE.

CHAMPAIGN COUNTY INFIRMARY. The original Champaign County Infirmary was established in 1847 and comprised of a 172-acre farm with a 2-acre garden and 23-acre orchard. The first main infirmary building was constructed in 1855 as a two-and-a-half-story brick building featuring a total of 35 rooms, with 9 rooms used for administrative purposes. Female inmates lived in the main building, while male inmates lived in a separate building with another building serving as the men's sitting room. The insane lived in an old frame-detached building. In 1890, an addition was added to the original building accommodating 100 inmates. The Ohio State Board of Charities reported the Champaign County Infirmary was considered above average in buildings and management. A new building was constructed in 1927 and operated as the county home until it was closed in the 1960s. (Above, courtesy of the Champaign County Library; below, courtesy of Jeffrey Hall Photography.)

DELAWARE COUNTY INFIRMARY.
Constructed in 1853 and expanded in 1870, the Delaware County Infirmary was 215 acres with a 43-room, two-story brick building containing 22 sleeping rooms. In 1893, a new building for the insane was constructed due to a fire destroying the original building. Closing in 1996, the infirmary's main building was demolished in 2012, leaving only the barn as a reminder of this public charity institution. (Courtesy of Jeffrey Hall Photography.)

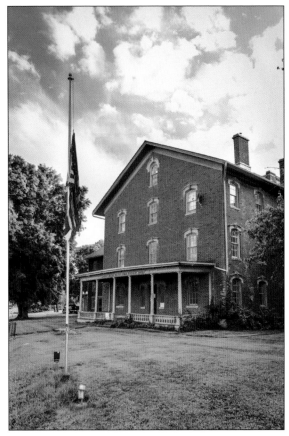

FAIRFIELD COUNTY INFIRMARY.
Established in 1828, the Fairfield County Infirmary was a farm of 178 acres with a three-story brick main building including 89 beds for inmates. A one-story detached building for the insane with six cells is also on the property. The infirmary operated until 1985, and recently, the Fairfield County commissioners sold the property. (Courtesy of Jeffrey Hall Photography.)

FAYETTE COUNTY INFIRMARY. Built in 1853, the Fayette County Infirmary was a 572-acre farm featuring a four-story brick building containing 57 rooms with 59 beds for inmates. The infirmary also has seven cells for insane inmates. The infirmary was abandoned in 1937 and sat empty for many years until it was demolished in 1958. (Courtesy of Jeffrey Hall Photography.)

FRANKLIN COUNTY INFIRMARY. Opening in 1832, the original Franklin County Infirmary moved to a new location in 1883. The farm was 98 acres with a large brick main building containing 98 rooms for 350 inmates. The infirmary operated until 1968 and was subsequently demolished. The land was used for the Alum Creek Nursing Home and later became the Regency Manor Rehabilitation and Subacute Center. (Courtesy of Jeffrey Hall Photography.)

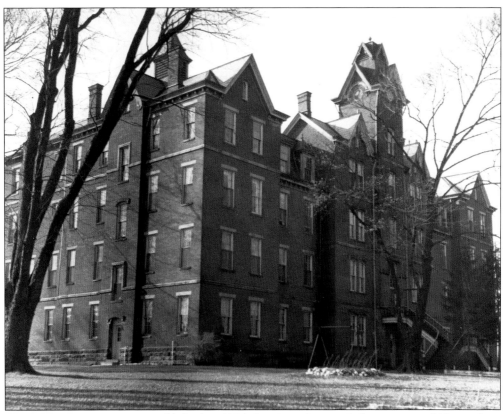

KNOX COUNTY INFIRMARY. Established in 1875, the Knox County Infirmary was a 309-acre farm with a four-story brick building containing 111 rooms, 17 of which are used for administrative purposes, including a kitchen, dining room, and seven rooms occupied by the superintendent. Apartments for inmates include a kitchen, dining room, 10 sitting rooms, and 44 sleeping rooms, including a room for "tramps" with four beds. The infirmary served the Knox County community until 1958, when the building was closed and sold to Mt. Vernon Bible College, which occupied the building until 1988. Sitting empty for many years, the infirmary was repurposed several more times until ultimately burning down in 2015. (Above, courtesy of Aubrey Brown; below, courtesy of Jeffrey Hall Photography.)

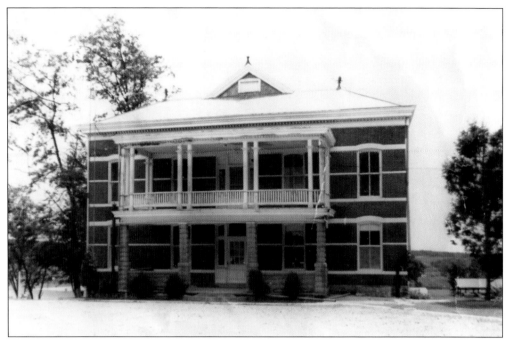

LICKING COUNTY INFIRMARY. Beginning in 1832, the Licking County Infirmary was originally a log house used to care for the county's poor. Replaced in 1862 with a two-story brick building, an addition was constructed in 1885, increasing space from two stories to three stories containing 40 rooms total. In 1883, the farm grew to 266 acres and, in 1909, the Licking County commissioners approved $3,000 to build a new barn on the site. In 1969, the superintendent of the infirmary was ordered by the county commissioners to move the residents to the Licking County Sanitarium building. Years of deterioration to the main infirmary building resulted in its demolition in 1997. Today, the former infirmary site is Infirmary Mound Park, part of the Licking Park District. (Above, courtesy of the Licking Park District; below, courtesy of Jeffrey Hall Photography.)

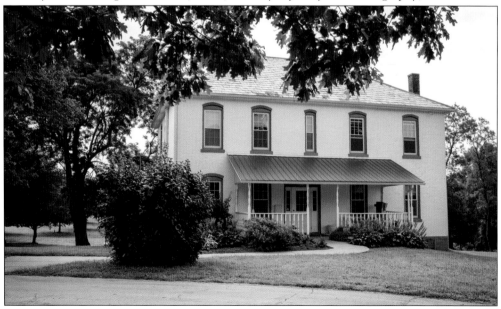

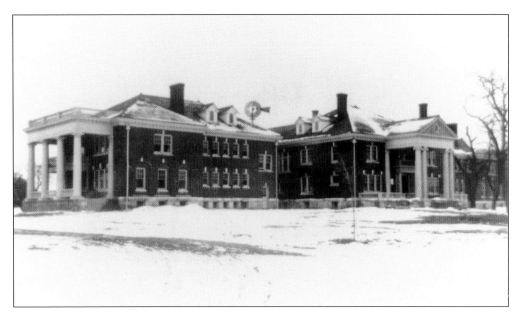

LOGAN COUNTY INFIRMARY, 1910 AND CURRENT SITE. The original Logan County Infirmary was a 180-acre farm with a two-story brick main building containing 20 rooms and 44 beds for inmates. Rebuilding in 1910, the home had a capacity of 100 inmates. The 1912 Ohio State Board of Charities annual report "considered the Logan County Infirmary modern and a model of its kind and the unfortunates living there are enjoying the comforts and luxuries unknown to them in their own homes." Operating until 1978, the infirmary closed and was ultimately demolished. Today, Logan Acres Senior Community occupies the former infirmary site. (Above, courtesy of the Logan County Historical Society; below, courtesy of Jeffrey Hall Photography.)

MADISON COUNTY INFIRMARY. Established in 1857, the Madison County Infirmary farm was 105 acres with a four-story brick building complete with a basement. The farm included a 10-acre orchard and a 3-acre garden. In 1909, it was reported by the Ohio State Board of Charities, "There is a pleasant reading room in which are found daily papers and magazines." The Madison County Infirmary closed in 1956, and the building was demolished. (Courtesy of Jeffrey Hall Photography.)

MARION COUNTY INFIRMARY. Founded in 1852, the Marion County Infirmary sat on 235 acres. The two-story building was brick with 23 rooms for inmates and administration. Female inmates occupied the main building, while male inmates lived in an old two-story frame building. There were 52 beds total for sleeping. The building was demolished. (Courtesy of Jeffrey Hall Photography.)

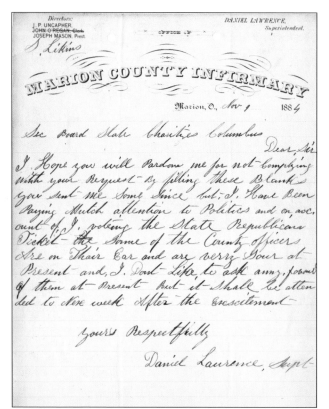

LETTER FROM MARION COUNTY INFIRMARY. Supt. Daniel Laurence wrote to Ohio State Board of Charities secretary Dr. Rev. Albert G. Byers noting the incomplete Annual Report of Infirmary Directors. While Superintendent Laurence was thought to be uniformly efficient and the domestic household of the infirmary was good, the 1883 Ohio State Board of Charities Annual Report recorded that Marion County had always been difficult in securing statistical reports. The blame was placed on the infirmary directors, not Superintendent Laurence, who would retire from his position around 1884. (Courtesy of the Ohio History Connection.)

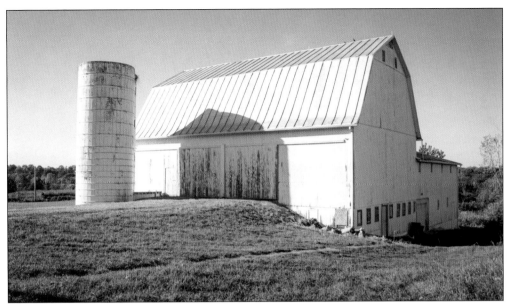

MORROW COUNTY INFIRMARY. Land was purchased in 1869 for a 200-acre infirmary farm with a one-acre garden and a six-acre orchard. A two-story brick building with an attic and 47 rooms was constructed for the inmates. The infirmary operated until 1986, when the main building was demolished. Some outbuildings remain. (Courtesy of Jeffrey Hall Photography.)

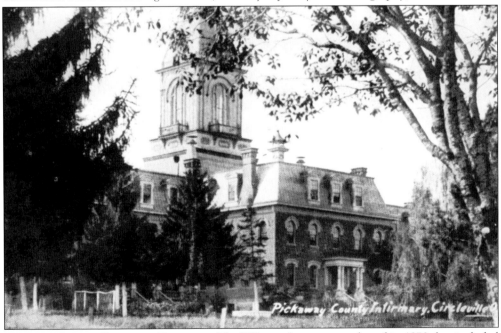

PICKAWAY COUNTY INFIRMARY POSTCARD. The 259-acre farm was purchased in 1870 that included a single-acre garden and a 14-acre orchard. The main building was erected in 1871 as a brick four-story structure, including a basement and attic, with 100 rooms to accommodate 132 beds for inmates. The original construction of this infirmary included a hospital wing, which was unique when the Ohio State Board of Charities was in its infancy. (Courtesy of The Pickaway County Historical and Genealogical Library.)

PICKAWAY COUNTY INFIRMARY TODAY. The Ohio State Board of Charities reported the main infirmary building was perhaps the best of its kind in the state because it provided for easy and entire separation of inmates and was heated by steam, well ventilated, and thoroughly drained and well managed. Closing in 1965, the Pickaway County Infirmary was demolished. (Courtesy of Jeffrey Hall Photography.)

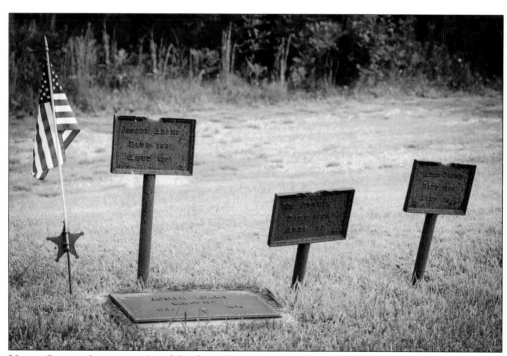

UNION COUNTY INFIRMARY. Land for the infirmary was purchased in 1850 with the construction of the first infirmary building in 1851. By 1871, a new four-story brick building containing 75 rooms on 150 acres was established. Operating until 1961, the Union County commissioners built a new county home called Union Manor. In 2001, Union Manor was officially closed. The original infirmary building has been demolished. (Courtesy of Jeffrey Hall Photography.)

Five

Infirmaries of Southwest Ohio

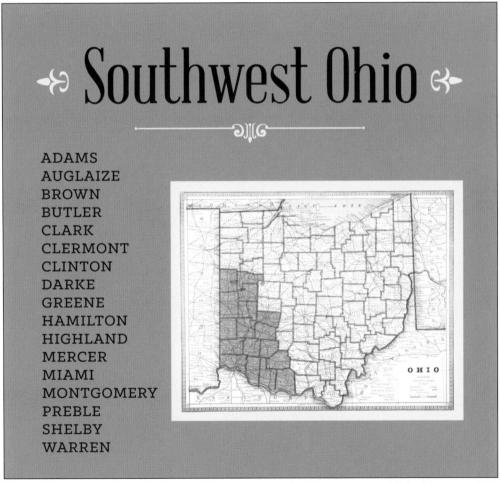

Southwest Ohio

ADAMS
AUGLAIZE
BROWN
BUTLER
CLARK
CLERMONT
CLINTON
DARKE
GREENE
HAMILTON
HIGHLAND
MERCER
MIAMI
MONTGOMERY
PREBLE
SHELBY
WARREN

OHIO

MAP OF SOUTHWEST OHIO. Southwest Ohio is comprised of 17 counties established between 1790 and 1819, and by 1886, each county built an infirmary. Many historical photographs of former infirmary buildings from this region in Ohio exist and are on exhibit at the Wood County Museum. (Courtesy of BGSU Center for Archival Collections and Abby Bender.)

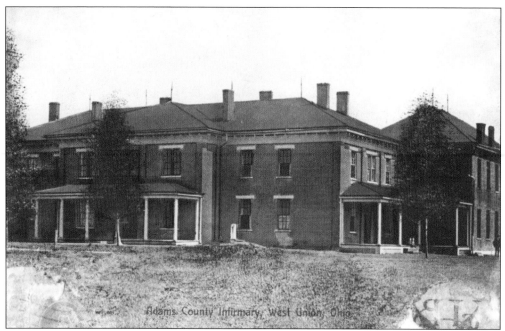

ADAMS COUNTY INFIRMARY. The Adams County commissioners purchased land in 1837 with the intention of constructing an infirmary for the local pauper population. The first building was erected in 1839 and made from brick and stone with a separate building for those deemed insane. By 1909, the farm was 640 acres, and it was reported that the main building and farm buildings were clean and in a good state of preservation. The inmates were well cared for with good food, clothing furnished, and proper medical attention. The former Adams County Infirmary is no longer owned by the county commissioners; instead, a private company operates the former infirmary known today as Adams County Manor. (Above, courtesy of Felicia Konrad-Bevard; below, courtesy of Jeffrey Hall Photography.)

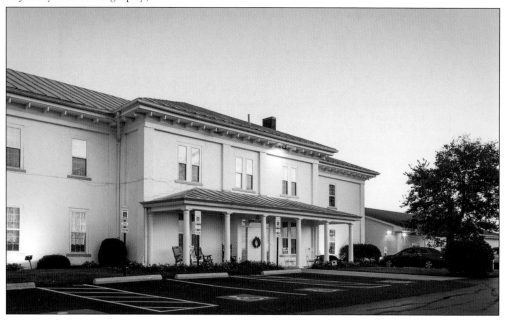

ADAMS COUNTY INFIRMARY CEMETERY. The Ohio State Board of Charities recommended each county set aside land for the purpose of creating a pauper cemetery. When a person died at a county-managed public charity building, arrangements were made to return the body to a family member for burial. If a pauper did not have family, then it was the responsibility of the county infirmary superintendent to arrange for burial in the infirmary cemetery. In some cases, county commissioners paid for the expense of engraving a name on the tombstone. In other cases, a deceased person's headstone was engraved with a number. That did not always mean the identity of the person was unknown. In most cases, a deceased person, the day of death, and even the cause of death were recorded, and the superintendent would decide whether to place an obituary in local newspapers or not. It was recommended and customary for funeral services to take place inside county homes prior to burial. (Courtesy of Jeffrey Hall Photography.)

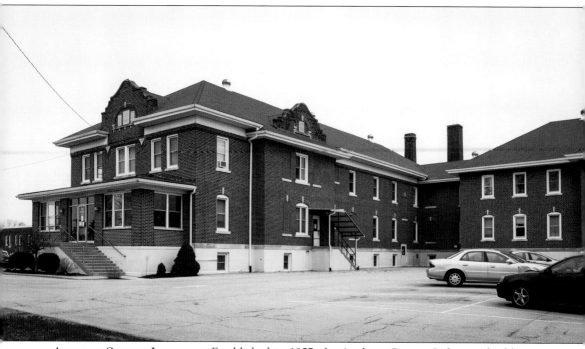

AUGLAIZE COUNTY INFIRMARY. Established in 1857, the Auglaize County Infirmary building sat on a 200-acre farm including 80 woodland acres. The main building originally was a two-story log house with the superintendent living in one side while the inmates lived on the other side. A separate residence was constructed for the superintendent's family in 1858, and a two-story brick structure containing 38 rooms was built in 1867. A fire destroyed the building in 1905. A new three-story brick infirmary with basement containing 26 rooms in all was built for the inmates including a kitchen, a dining room, and 13 sleeping rooms with 23 beds. In 2018, the Auglaize County Commissioners made the decision to privatize the county nursing home. Alternative Living Solutions purchased the site and rebranded as The Acres of Wapakoneta. (Courtesy of Jeffrey Hall Photography.)

AUGLAIZE COUNTY INFIRMARY BUTCHERING (ABOVE) AND ETCHING (BELOW). The profitability of infirmary farms was dependent on the quality of labor provided to work the acreage by the inmates. It was also not uncommon to butcher animals for consumption, especially hogs, on the infirmary site; however, the Ohio State Board of Charities questioned the efficiency of labor in exchange for room and board simply because, over time, the occupants of the county infirmaries were physically unable to "help on the farm." Instead, superintendents were required to hire outside help to complete the tasks of farming and butchering, leading to the question of "whether it were cheaper to buy grain and meat and have simply pasturage and a large vegetable garden, than to farm extensively." (Above, courtesy of Auglaize County Commissioners; below, courtesy of Bowling Green State University Center for Archival Collections.)

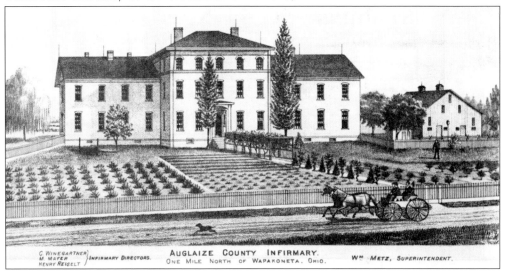

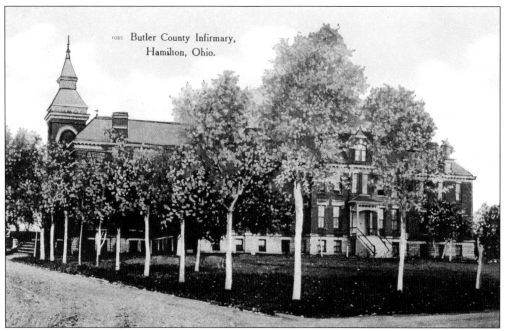

1085 Butler County Infirmary,
Hamilton, Ohio.

BUTLER COUNTY INFIRMARY. As early as 1831, the Butler County commissioners purchased a tract of land to construct an infirmary building. The farm was 192 acres with 140 acres of tillable land including a 2-acre garden and 10-acre orchard. A two-story brick building with a basement and 14 rooms served the paupers of Butler County until 1884, when the decision was made to build a new and more modern infirmary structure. Opening in 1885, the new four-story building included a basement and attic with a kitchen, two dining rooms, four sitting rooms, bathrooms, and closets. The insane of Butler County lived in an old three-story stone building. By 1976, the need for a new county infirmary was realized, and the decision was made to demolish the old infirmary and move to a new site known today as the Butler County Care Facility. (Above, courtesy of the Smith Library of Regional History; below, courtesy of Jeffrey Hall Photography.)

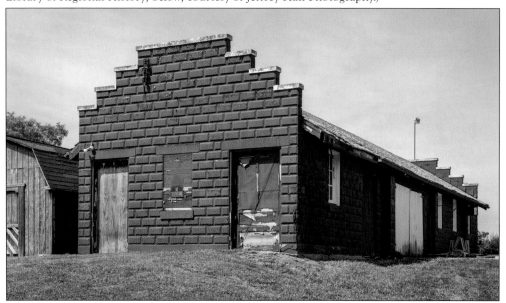

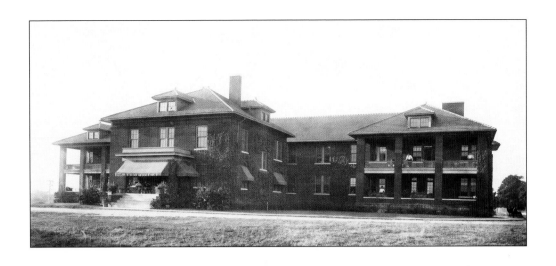

CLARK COUNTY INFIRMARY. Established in 1834, the 69-acre farm originally contained a brick, two-story main building with 76 rooms. The Ohio State Board of Charities routinely noted the ill arrangement of the first set of infirmary buildings, yet complimented the efficiency of management. Improvements were made to the original site, but in 1916, county commissioners decided to construct a brand new brick, 55-room building on a 157-acre farm. The infirmary operated until 1986 when the county commissioners closed it due to low numbers of occupancy. The home was auctioned to a private individual. (Above, courtesy of the Clark County Historical Society at the Heritage Center; below, courtesy of Jeffrey Hall Photography.)

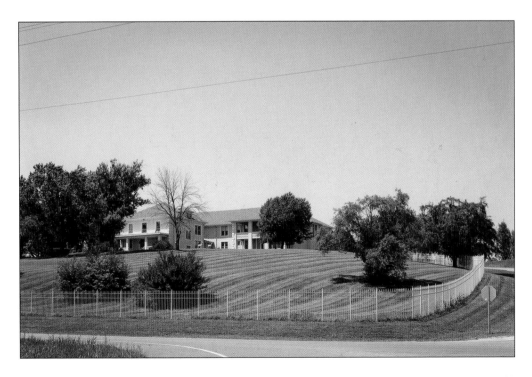

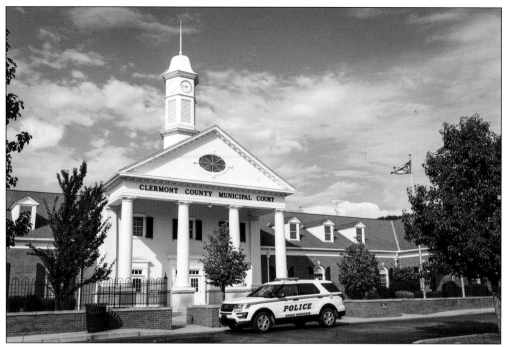

CLERMONT COUNTY INFIRMARY. The original 1854 Clermont County Infirmary consisted of 108 acres in Batavia Township. Two years later, in 1856, the county commissioners purchased new land for a 120-acre infirmary farm, and a new infirmary building was constructed in 1857 until it was destroyed by fire in 1877. A brick, three-story structure with a basement containing 72 rooms served inmates until 1965, and the building was demolished in 2002. (Courtesy of Jeffrey Hall Photography.)

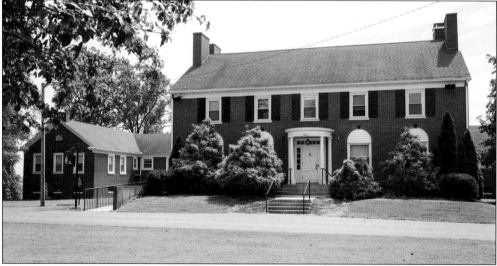

CLINTON COUNTY INFIRMARY. Founded in 1835, the Clinton County Infirmary was a 347-acre farm with a 2-acre garden and a 5-acre orchard. The main building was a brick, two-story structure trimmed with stone containing 56 rooms. Adhering to the recommendations of the Ohio State Board of Charities, in 1928, the Clinton County Infirmary constructed a new hospital-style building to care for the county's poor and aged. (Courtesy of Jeffrey Hall Photography.)

CLINTON COUNTY INFIRMARY ARCHITECTURAL DRAWING. Opening in 1929, the new Clinton County Infirmary followed the new guidelines set by the Ohio State Board of Charities. No longer were able-body inmates working large tracts of farmland. Instead, the feeble-minded and the elderly inhabited these large and inefficient buildings. One-story hospitals were recommended to treat people with chronic illnesses. The building was divided into four wings: administrative, male and female wings, and a service wing that included the kitchen and dining rooms. Today, the former Clinton County Infirmary building is owned by Wilmington College. (Both, courtesy of the Ohio History Connection.)

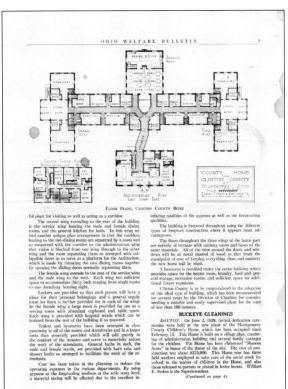

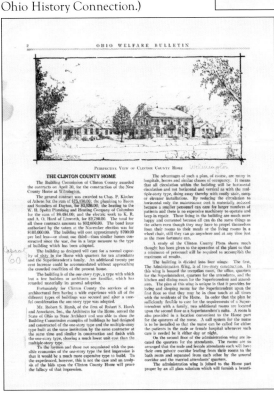

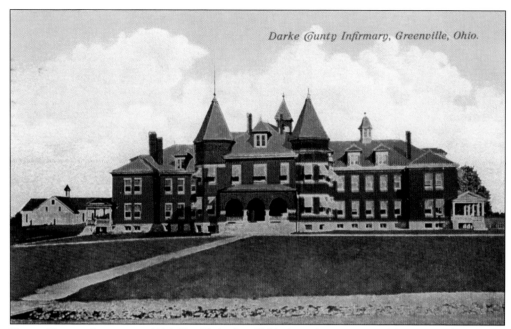

Darke County Infirmary, Greenville, Ohio.

DARKE COUNTY INFIRMARY, 1898. Established in 1854, the infirmary sat on 247 acres with 210 acres under cultivation. There was also a 6-acre garden and a 12-acre orchard. The first Darke County Infirmary was a three-story brick building with a basement containing 74 rooms with 14 rooms used for administration. The inmates had 2 dining rooms, 37 bedrooms, and 5 small cells for the insane. An addition was added to the home in 1875. A fire destroyed the building in 1897 but was rebuilt and opened in 1898 and remained in operation until 1976, when the building was struck by lightning and burned down. The third and more modern county infirmary opened in 1978 and is still known today as the Darke County Home. (Both, courtesy of Felicia Konrad-Bevard and the Ohio History Connection.)

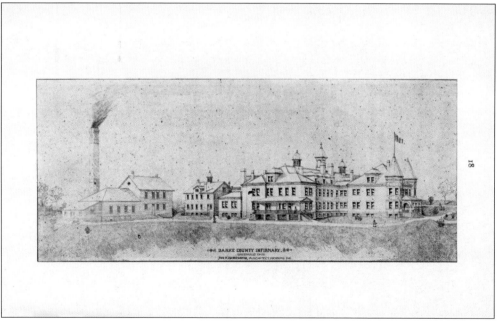

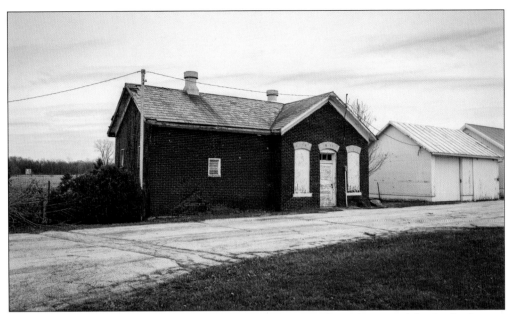

DARKE COUNTY INFIRMARY OUTBUILDING AND CEMETERY. In the early years of the Darke County Infirmary, it was reported 450 bushels of apples, 1,295 bushels of wheat, 578 bushels of oats, 5 bushels of clover seed, 3,300 bushels of corn, 1,050 bushels of potatoes, and 5,500 heads of cabbage. It was noted by the secretary of the Ohio State Board of Charities that the Darke County Infirmary was intelligently and kindly managed. According to research provided by the Greenville Public Library, demographic information, including name and date of death, related to the inhabitants of the pauper cemetery was recorded. Interestingly, only veterans had their names engraved on the headstone. (Both, courtesy of Jeffrey Hall Photography.)

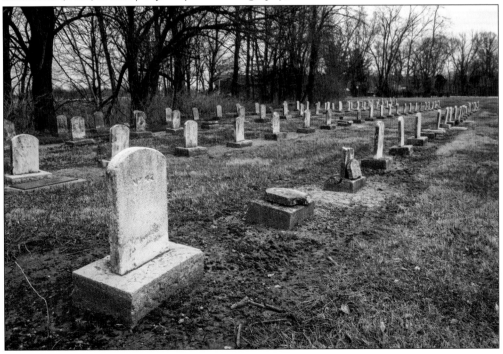

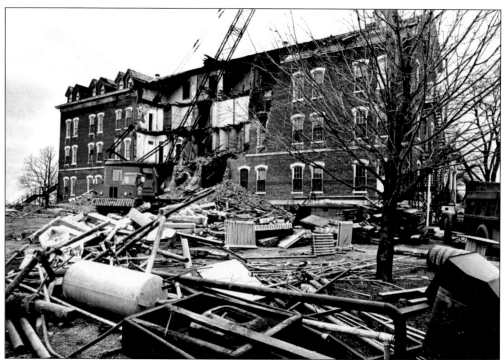

GREENE COUNTY INFIRMARY DEMOLITION. Noted as having superior management in the 1870s, the Greene County Infirmary was known as one of the neatest and most comfortable arrangements in the state. The "colored management department" was run by Eliza Bryant and considered one of the best-ordered households when reviewed by the Ohio State Board of Charities for the annual report. The original infirmary building was built in 1828 and used until 1869, when county commissioners approved the construction of a new brick structure. Comprised of five stories, the brick building had a basement and attic containing in all 65 rooms with 18 rooms for administrative purposes. Also included were 2 dining rooms, 2 male sitting rooms, and 38 sleeping rooms with 60 beds. (Both, courtesy of Greene County Records Center & Archives.)

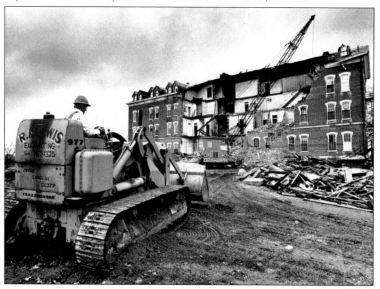

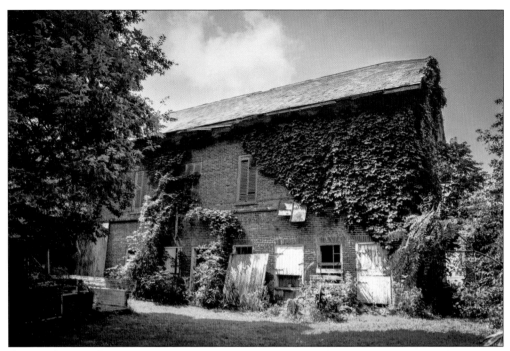

GREENE COUNTY INFIRMARY OUTBUILDING. Farmland for the county infirmary site was purchased in 1816, consisting of 104 acres with 60 acres of woods and pasture. A large barn was constructed on the property in 1839 under the direction of the county commissioners. According to the Ohio State Board of Charities 1871 annual report, the Greene County Infirmary was called a model institution with a determination to make this infirmary a comfortable home for the poor. While updates and changes occurred to the original infirmary building over the course of 129 years, in 1975, it was decided to construct a modern nursing home facility. Opening in 1977, Greenwood Manor still serves the residents of Greene County with skilled and intermediate nursing care. (Both, courtesy of Jeffrey Hall Photography.)

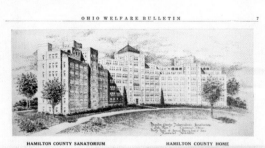

HAMILTON COUNTY SANATORIUM

This imposing structure is not a mere dream of some architect, but is fast becoming an actual agent in fighting tuberculosis in Hamilton County.

In 1927 a bond issue was favorably voted. From this the central portion of the structure was erected and was occupied February 5, 1929. In 1928 an additional issue of $2,000,000 was authorized. From this sum the right wing, or pavilion, is being erected and will be finished within sixty days. After this a completed, plans will be drawn for the left wing, which it is to be devoted to the care of children. The Nurses' Home of one hundred and five rooms was also constructed out of the last bond issue.

The main portion and right pavilion have accommodations for two hundred and thirty-eight patients, in addition to offices, treatment rooms, laboratories, etc. When the entire structure is finished, more than four hundred persons can be cared for.

HAMILTON COUNTY HOME

For about a year the new Hospital of the Hamilton County Home has been occupied. Its erection was authorized in 1927, when a bond issue of $280,000 was approved by the voters. This building has accommodations for sixty-seven patients and is kept filled with sick and disabled inmates of the large Institution.

The Commissioners will probably submit to the electors this Fall the question of raising about $2,000,000 to replace the main parts of the County Home, which are said to be at least one hundred years old, and beyond repair except at an enormous cost.

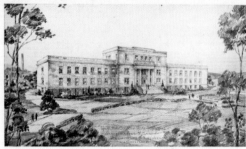

NEW HOSPITAL, HAMILTON COUNTY HOME, CINCINNATI
Rendigs, Panzer & Martin, Architects

HAMILTON COUNTY INFIRMARY– HAMILTON COUNTY HOSPITAL. Opening in 1851, The Hamilton County Infirmary established a new building in 1871 on a 120-acre farm including a 10-acre orchard and 10-acre garden. The building was a brick, four-story structure with a basement containing 73 rooms to accommodate 222 beds for inmates. In 1927, the Hamilton County commissioners authorized the construction of a hospital building to care for the county's infirm. (Courtesy of Ohio History Connection.)

HAMILTON COUNTY INFIRMARY/DRAKE CENTER FOR ACUTE CARE. Closing in 1952, the Hamilton County Hospital was replaced with a five-story, 340-bed facility. It was named for Daniel Drake, the first person west of the Appalachian Mountains to earn a medical degree; he was instrumental in the formation of medicine in Ohio. (Courtesy of Jeffrey Hall Photography.)

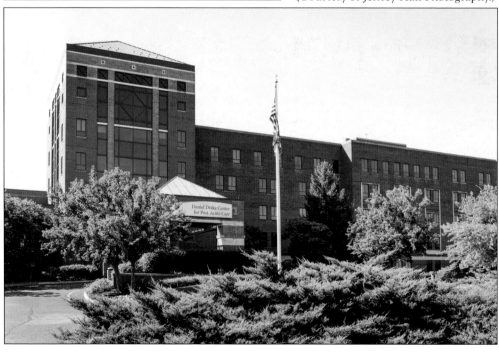

HIGHLAND COUNTY INFIRMARY. Opening in 1842, the Highland County Infirmary farm was 475 acres with a two-story main building with 24 sleeping rooms and a total of 60 beds for inmates. In operation until 1971, the main building was demolished in 1972. This barn is one of the few remnants of the county home. (Courtesy of Jeffrey Hall Photography.)

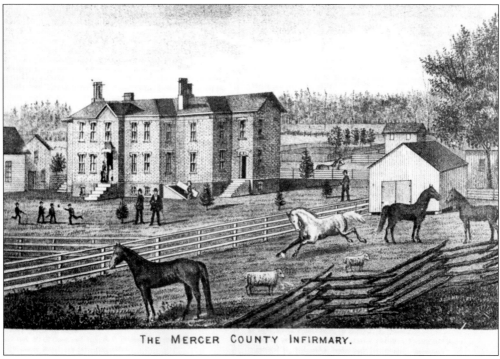

THE MERCER COUNTY INFIRMARY.

MERCER COUNTY INFIRMARY ETCHING, C. 1875. The infirmary farm was made up of 326 acres with 145 acres under cultivation. It was reported the farm produced the finest corn and tenderest vegetables in abundance. The big onsite cattle barn was furnished with a cement floor so cows could produce a milk supply in clean quarters. It was also noted the Mercer County Infirmary raised over 1,000 chickens. Hundreds of bushels of potatoes, four barrels of kraut, 1,700 cans of fruit, and gallons of fruit butter were made for the 1908 winter supply. Good, plain, and wholesome food is served daily, and special dinners are provided to the inmates on holidays. Evidence of the productiveness of the season's harvest was noted in the amount of food stored away for the winter. Mercer County Infirmary was noted as a model institution. Infirmary management was considered fair and kind-hearted. (Courtesy of Bowling Green State University Center for Archival Collections.)

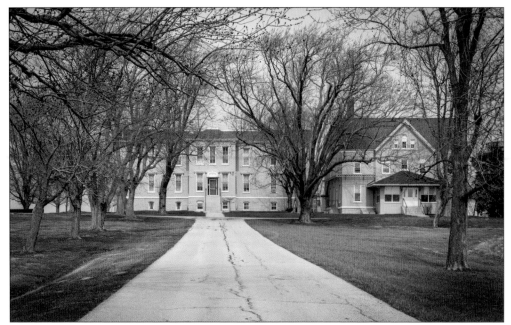

MERCER COUNTY INFIRMARY. Infirmary land was purchased in 1865, complete with an old, strong-framed log building for inmates. By 1875, the Mercer County commissioners recognized the need for a better structure and built a two-story brick building with 22 rooms. The superintendent occupied seven rooms for administrative purposes. By 1908, the site was made up of four buildings, two brick and two framed, used as houses for inmates. It was noted by the board of county visitors the cleanliness of buildings and general air of comfort throughout the infirmary. The supply of water proved difficult, and it was recommended that a pump be installed in the laundry building. Today, the Mercer County commissioners still maintain a county-managed nursing home. (Both, courtesy of Jeffrey Hall Photography.)

MIAMI COUNTY INFIRMARY. Established in 1836, the Miami County Infirmary farm was first constructed in 1840. By 1852, the county commissioners recognized the need for a new building, and, in 1854 a two-story brick structure with an attic was opened. In 1886, a separate brick building on the 154-acre farm was constructed to house the county's insane cases. (Courtesy of Jeffrey Hall Photography.)

MIAMI COUNTY INFIRMARY, MIAMI COUNTY SERVICES BUILDING. A new version of Miami County Home was constructed in 1927, and a new barn was built in 1930 to replace the previous barn destroyed by fire. Today, the Miami County Community Services Center occupies the former infirmary building, offering a variety of social services for local community members. (Courtesy of Jeffrey Hall Photography.)

PREBLE COUNTY INFIRMARY. Founded in 1835, the Preble County Infirmary farm was 193 acres with a brick, two-story building containing 27 rooms with 11 rooms used for administration including a separate dining room and kitchen. Separation of sexes is maintained with the men eating in the kitchen and the women eating in the dining room. The inmates had 25 sleeping beds in all. Additions to the original structure occurred in 1899, 1911, and 1921. Two buildings for the insane and a two-story brick boiler house accommodating a bakery on the first floor and a nursery on the second floor were also part of the site. This county infirmary was found to maintain a high standard of excellence with the best order, system, and management in caring for the inmates. The general condition of the site was clean, comfortable, and neat. This site was demolished in 1989. (Courtesy of Jeffrey Hall Photography.)

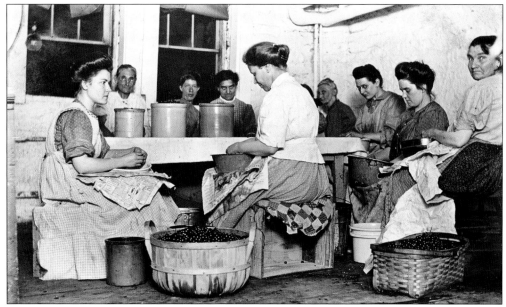

SHELBY COUNTY INFIRMARY. Opening in 1865, the Shelby County Infirmary occupied 200 acres of land with 180 acres cultivated. The original main building was a two-story brick structure and expanded to a three-story brick building in 1869 containing 43 rooms. The inmates enjoyed a kitchen, 2 dining rooms, 2 sitting rooms, and 24 bedrooms with 54 beds. The infirmary administration occupied five rooms including a separate dining room and kitchen. The building for the insane was a one-story brick building connected to the main building with an open-covered corridor. The house and household were remarked as being well cared for and in comfortable keeping. This building was in operation until 1969, when a new Shelby County home known as Fair Haven opened to serve the local elderly community. (Above, courtesy of the Shelby County Historical Society; below, courtesy of Jeffrey Hall Photography.)

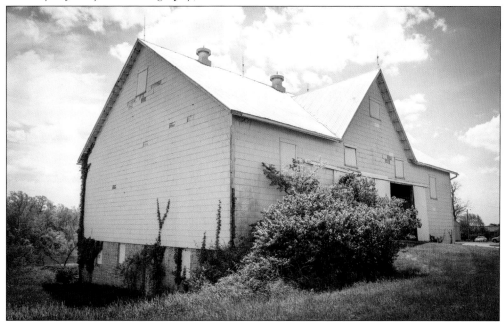

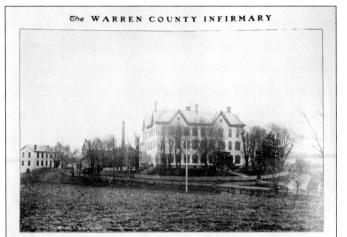

The following text appears within the above image (period newspaper-style article, largely illegible at this resolution):

WARREN COUNTY INFIRMARY.
Opening in 1831, the
original Warren County
Infirmary consisted of a
two-story brick building that
succumbed to fire. Rebuilt
in 1867, the new brick
three-story building with
a basement contained 90
rooms. The structure sat on
105 acres of farmland with
a 5-acre garden for inmates.
Even though precautions
were made to prevent
another fire, the Warren
County Infirmary burned
down again and was rebuilt
in 1916. Closing as the
county infirmary in 1967,
the building is still owned
by Warren County. (Above,
courtesy of Bowling Green
State University Center
for Archival Collections;
below, courtesy of Jeffrey
Hall Photography.)

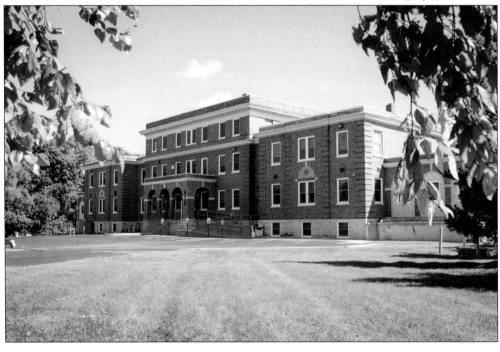

Six

INFIRMARIES OF SOUTHEAST OHIO

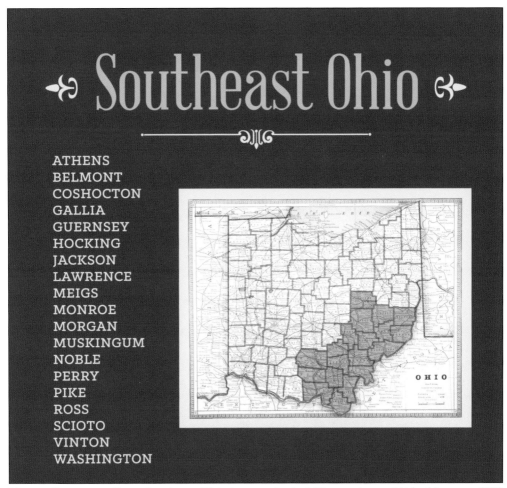

Southeast Ohio

ATHENS
BELMONT
COSHOCTON
GALLIA
GUERNSEY
HOCKING
JACKSON
LAWRENCE
MEIGS
MONROE
MORGAN
MUSKINGUM
NOBLE
PERRY
PIKE
ROSS
SCIOTO
VINTON
WASHINGTON

MAP OF SOUTHEAST OHIO. Southeast Ohio is comprised of 19 counties established between 1778 and 1851, and by 1874, each county constructed a poorhouse. Many historical photographs of former infirmary buildings from this region in Ohio exist and are on exhibit at the Wood County Museum. (Courtesy of BGSU Center for Archival Collections and Abby Bender.)

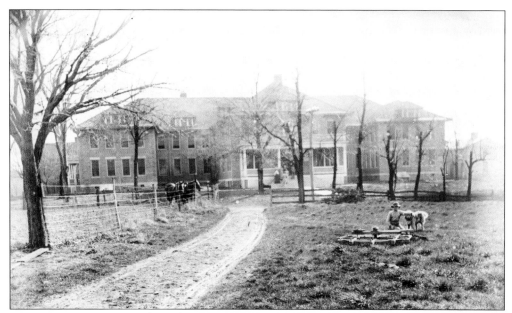

ATHENS COUNTY INFIRMARY (ABOVE) AND ATHENS COUNTY JOB AND FAMILY SERVICES (BELOW). Opening in 1857, the Athens County Infirmary farm was 139 acres with a one-and-a-half-acre garden and three-acre orchard. The original main building was a two-story brick L-shaped structure containing 20 rooms with 20 beds for inmates and a two-story frame building with nine cells with open wood studding for the insane. In 1905, a new building was completed to accommodate 100 inmates. The Ohio State Board of Charities said the Athens County Infirmary's "general condition and management is commendable in view of the limited facilities for the care of a most troublesome class of inmates." In operation as an infirmary until 1997, the facility is still owned by the county and is currently home to Athens County Job and Family Services. (Above, courtesy of Southeastern Ohio History Center; below, courtesy of Jeffrey Hall Photography.)

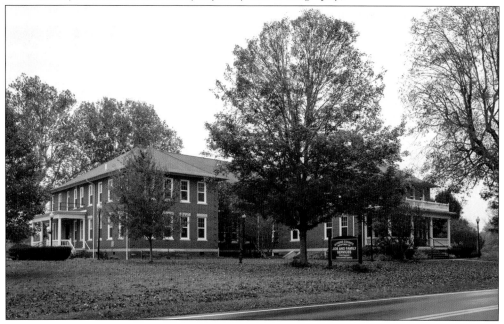

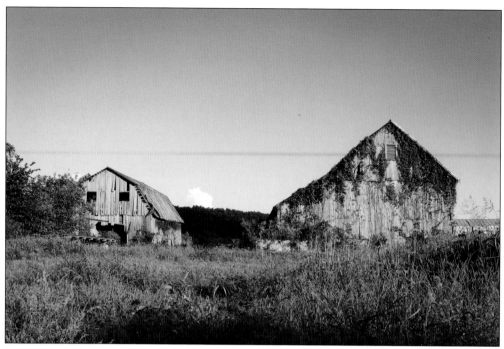

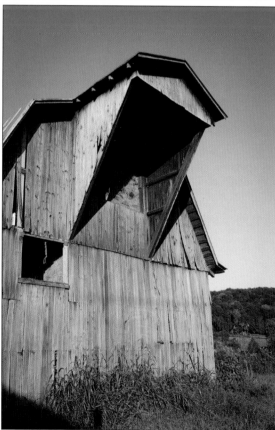

PIKE COUNTY INFIRMARY OUTBUILDINGS. Opening in 1855, the infirmary originally consisted of 400 acres, eventually trimmed down to 200 acres, with 125 acres of land under cultivation. The main infirmary building started out as a one-story frame construction. Improvements expanded living space to a two-story frame building with 11 rooms, 3 of which were used for administrative purposes, including a separate kitchen and dining room. (Courtesy of Jeffrey Hall Photography.)

PIKE COUNTY INFIRMARY BARN. Inmates enjoyed a kitchen, dining room, sitting room, 3 sleeping rooms, and 13 cells for the insane. Very little information about Pike County Infirmary was located, and it is unclear when the main building was demolished. Today, the former infirmary site is privately owned. These outbuildings are all that remain of the former public charity building. (Courtesy of Jeffrey Hall Photography.)

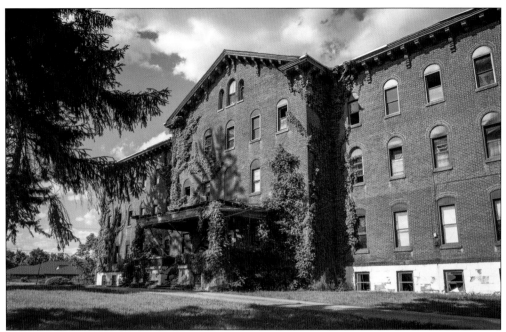

BELMONT COUNTY INFIRMARY. Established in 1828, the Belmont County Infirmary farm was 182 acres with a 5-acre orchard. From the time the infirmary opened until 1870, the main brick building underwent a series of additions and improvements. Needing a more efficient space, the 1870 version of the infirmary consisted of a four-story brick building of 140 rooms with 42 sleeping rooms containing 72 beds. A two-story brick hospital building was also constructed as a separate structure from the main building. The 1885 Ohio State Board of Charities annual report noted, "The premises and buildings were neat, in good condition, and from appearances the management was doing everything possible to keep the house in order and to promote the comfort of the household." Closed and abandoned for many years, the Belmont County commissioners are in the process of scheduling the demolition of this site. (Both, courtesy of Jeffrey Hall Photography.)

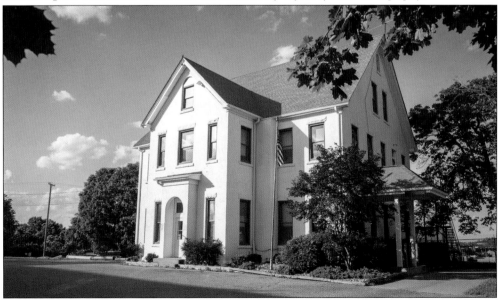

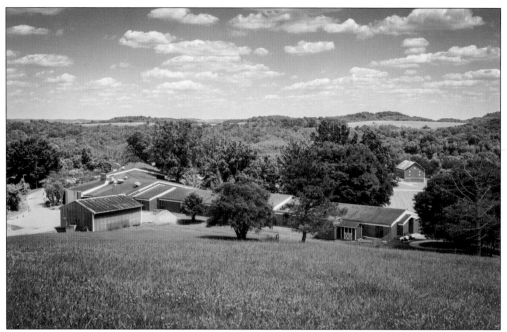

COSHOCTON COUNTY INFIRMARY. Opening in 1848, the Coshocton County Infirmary was 309 acres total with a 15-acre orchard and 180 acres of ordinary farming. The original portion of the main building was a two-story brick structure with a basement. A three-story addition with a basement was added totaling 43 rooms with 26 sleeping rooms and 9 rooms used for administrative purposes. A one-story brick building was constructed for the insane. The Coshocton County Infirmary was in operation until 1976, when a new county home was constructed. The original structure was demolished. In 1927 a man, named Ed Sweeny, published a book called *Poorhouse Sweeny*, a first-person narrative of life at the Coshocton County Infirmary. (Both, courtesy of Jeffrey Hall Photography.)

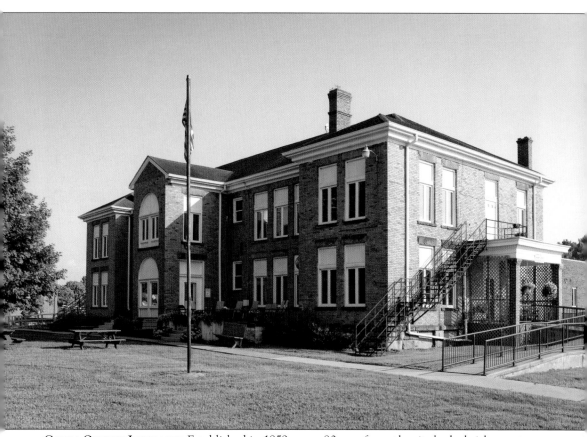

GALLIA COUNTY INFIRMARY. Established in 1859 on an 80-acre farm, the site had a brick one-story house for the superintendent and three brick one-story buildings for the inmates. A separate one-story building was constructed for "colored" inmates. Three buildings were combined for the inmates containing a kitchen, 2 dining rooms, and 24 sleeping rooms. Unfortunately, the Ohio State Board of Charities noted, the original one-story building considered economy over comfort and convenience for both the superintendent and inmates. The superintendent and matron, Samuel and Nancy Hott, were considered kind-hearted people, and with the proper facilities their work would improve if able to secure better conditions for the inmates. Fortunately, around 1906 the original dilapidated infirmary building was demolished and a new infirmary building was constructed, known today as the Gallia County Senior Center. (Courtesy of Jeffery Hall Photography.)

GUERNSEY COUNTY INFIRMARY. The 166-acre farm in Guernsey County was purchased in 1841 complete with a small brick building for inmates. By 1859, the need for a larger building prompted the construction of a three-story brick building with 42 rooms. The superintendent and family occupied a separate 10-room brick house. By the early 1900s, the farm grew to 212 acres. Conveniences of the home included four bathtubs, allowing for all inmates to bathe once a week, and plenty of clean clothing available. The superintendent also provided very comfortable beds with clean bedding in good condition for the inmates. As the Ohio State Board of Charities recommended, the Guernsey County Infirmary was well stocked with plenty of good reading materials, including religious papers and magazines. This site was in operation until 1975, when a modern nursing home facility was constructed, known today as Countryview Assisted Living Center. (Both, courtesy of Jeffrey Hall Photography.)

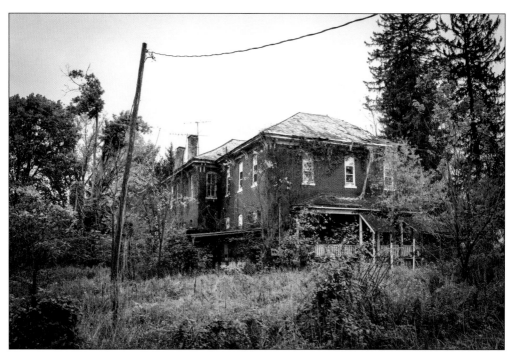

HOCKING COUNTY INFIRMARY. Built in 1870, the Hocking County Infirmary was a 220-acre farm complete with a two-story brick main building containing a basement, kitchen, dining room, and a common room for inmates. In all, there were 11 rooms with 27 beds for inmates. A one-story brick building was for the insane inmates. (Courtesy of Jeffrey Hall Photography.)

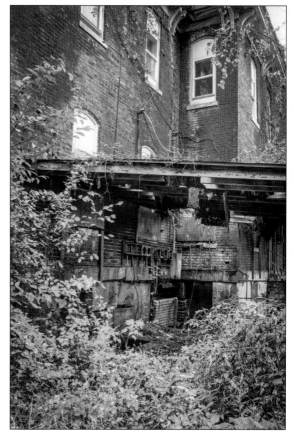

HOCKING COUNTY INFIRMARY NOW. Over the course of 85 years, the Hocking County Infirmary served the indigent of the local community. Sometime before July 1959, the Hocking County commissioners decided to sell the farm and get out of "the nursing home business." The building still stands today on State Route 328 and is used as rental apartments. (Courtesy of Jeffrey Hall Photography.)

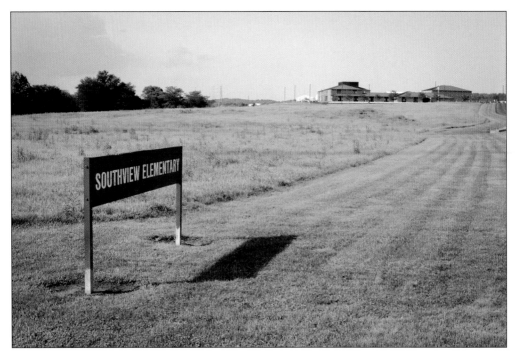

JACKSON COUNTY INFIRMARY. Constructed in 1870, the Jackson County Infirmary started as a 160-acre farm until 1876, when 80 acres of the farm were sold. Additionally, there was an eight-acre garden and cemetery. The building was a brick three-story structure with a basement, kitchen, dining room, two sitting rooms, and seven bedrooms with 36 beds. The site was demolished, and today Southview Elementary occupies the former infirmary grounds. (Courtesy of Jeffrey Hall Photography.)

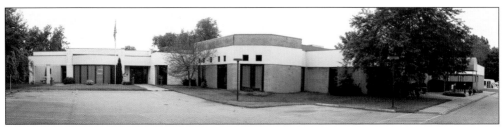

LAWRENCE COUNTY INFIRMARY. Opening around 1868, the Lawrence County Infirmary sat on 85 acres with a three-story brick main building containing 53 rooms, a shared kitchen and dining room between the superintendent and inmates, 2 sitting rooms, 31 sleeping rooms with 38 beds, and two cells for the insane. Demolished around 1979, information on this site is scarce. At one time, Tristate Industries occupied the former infirmary site. (Courtesy of Jeffery Hall Photography.)

MEIGS COUNTY INFIRMARY. Erected in 1868, the Meigs County Infirmary was a 100-acre farm. The main building was a two-story frame and brick building with 20 rooms. There is also a kitchen, a dining room, two sitting rooms, and eight bedrooms. In all, there were 70 beds for inmates. (Courtesy of Jeffrey Hall Photography.)

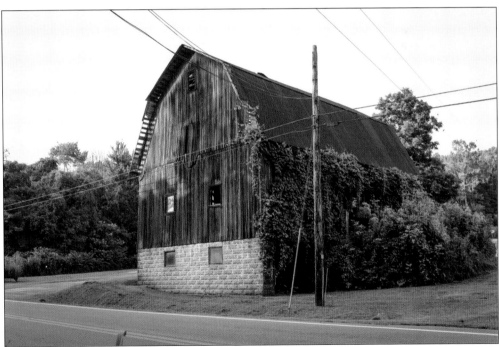

MEIGS COUNTY INFIRMARY NOW. Grates and stoves heated the infirmary with very little ventilation. Drainage for water supply came from a well and cisterns. Occasionally, water was supplemented from the nearby creek. A hose and force pump was used as a provision against fire. A detached two-story home was built for the insane. The home was demolished, but outbuildings remain on the property. (Courtesy of Jeffrey Hall Photography.)

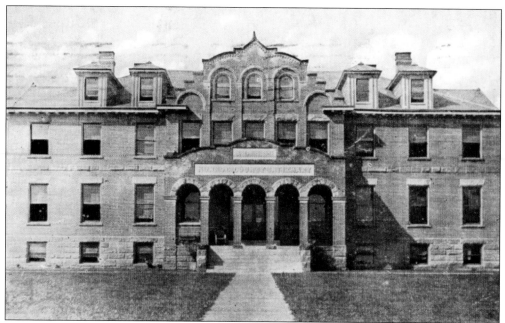

MONROE COUNTY INFIRMARY. Established in 1854 with the purchase of a 120-acre farm the original Monroe County Infirmary was a two-story brick building with 13 rooms. Administration occupied a portion of the main building, including a separate kitchen and dining room. Inmates had their own kitchen. For many years, the Ohio State Board of Charities called the Monroe County Infirmary void of conveniences and urged county commissioners to construct a new building. In 1899, a modern structure opened to the public and was in operation until 1978, then became known as the Monroe County Care Center. (Above, courtesy of Felicia Konrad-Bevard; below, courtesy of Jeffrey Hall Photography.)

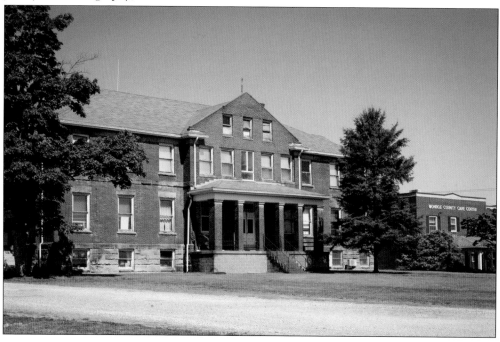

MORGAN COUNTY INFIRMARY BARN. In 1849, the Morgan County commissioners purchased a farm of 312 acres with 250 acres under cultivation, including a 3-acre garden and a 2-acre orchard. The main building is a two-story brick with an attic containing 48 rooms, a separate kitchen, a dining room, 2 sitting rooms, and 31 bedrooms with 43 beds for sleeping. There are four cells and two beds for the insane. (Courtesy of Jeffrey Hall Photography.)

MORGAN COUNTY INFIRMARY CEMETERY. The Morgan County Infirmary had a quarter acre set aside for a cemetery. Some information about those buried in the Morgan County Cemetery can be found on *Find a Grave*. The main building was demolished in 1975, but some outbuildings remain. (Courtesy of Jeffrey Hall Photography.)

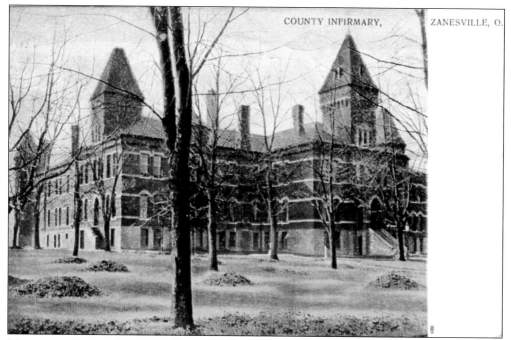

MUSKINGUM COUNTY INFIRMARY POSTCARD. Originally constructed in 1839 on a farm of 100 acres, the Muskingum County Infirmary partially burned down in 1859 and was rebuilt and enlarged. By 1880, it was decided the original county home was too old, and in 1881 a new two-story brick building with a basement and 109 rooms was constructed on the now 218-acre farm. (Courtesy of Felicia Konrad-Bevard.)

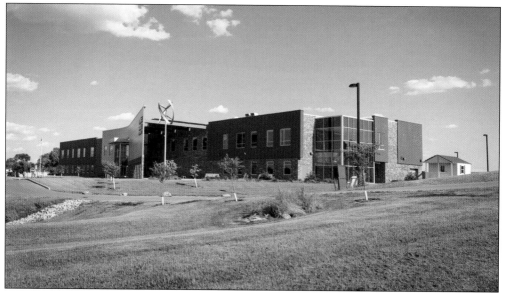

ZANE STATE COLLEGE ON FORMER MUSKINGUM COUNTY INFIRMARY LAND. The 1881 version of the Muskingum County Infirmary included 14 rooms for administration, a separate kitchen for inmates, 2 dining rooms, 4 sitting rooms, and 89 bedrooms, including 8 rooms for the insane. This infirmary site closed in 2008 and was demolished in 2012. Today, Zane State College occupies the former infirmary site. (Courtesy of Jeffrey Hall Photography.)

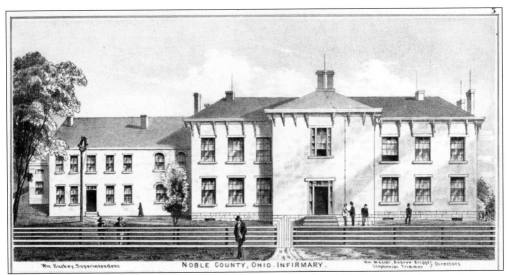

NOBLE COUNTY INFIRMARY ETCHING. Established in 1861, the Noble County Infirmary farm was 400 acres with 315 under cultivation, including an 8-acre orchard. The main building was two-story brick containing 24 rooms with 40 sleeping beds. The same space was used for both the dining and sitting rooms. (Courtesy of Bowling Green State University Center for Archival Collections.)

NOBLE COUNTY INFIRMARY SITE. Information related to the Noble County Infirmary was difficult to locate and an exact date of demolition has not been established. The Noble County Infirmary Cemetery is on Old Infirmary Road or County Road 21 in Caldwell, Ohio. The Noble County Genealogical Society has done some work researching the inhabitants of the cemetery. (Courtesy of Jeffrey Hall Photography.)

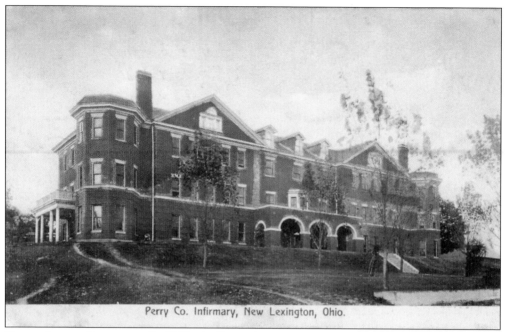

Perry Co. Infirmary, New Lexington, Ohio.

PERRY COUNTY INFIRMARY. In 1839, the Perry County commissioners purchased 200 acres of farmland for a county infirmary and erected a two-story brick building in 1848. Over the years, additions were made to the site increasing capacity and comfort for the inmates with 53 rooms. There were 25 bedrooms with 45 beds, a kitchen, a dining room, and halls used as sitting rooms. The superintendent occupied 12 rooms for administrative purposes including a separated kitchen and dining room. The building for the insane was a one-story brick house detached from the main building with six small cells and eight beds. (Above, courtesy of Felicia Konrad-Bevard; below, courtesy of the Ohio History Connection.)

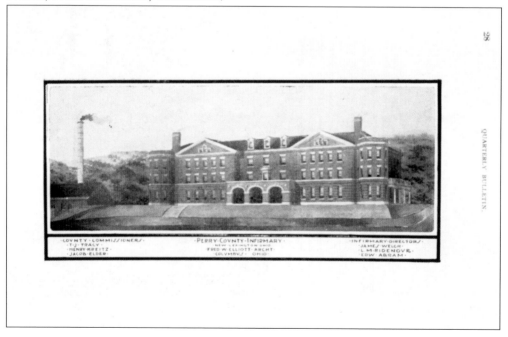

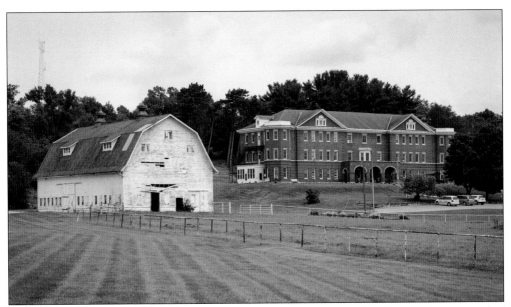

PERRY COUNTY INFIRMARY SITE AND STAIRCASE. Under the advisement of the Ohio State Board of Charities, the Perry County commissioners decided to hire Columbus, Ohio, architect Fred W. Elliot to design the new county home. Opening in 1902, the three-story brick building contained dormitory space, separate hospital wards for male and female inmates, a sewing room for female residents, two sitting rooms, two dining rooms, a room for the deceased, and rooms specifically for elderly couples. There were also separate living quarters for the superintendent, including a private kitchen and dining room. Rooms were well ventilated; there was plenty of fresh air, and living conditions were reported as very neat and satisfactory. Today, the Perry County Infirmary is still in operation known as Fairview Assisted Living. (Both, courtesy of Jeffrey Hall Photography.)

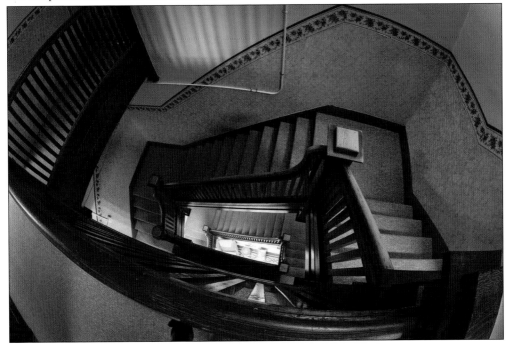

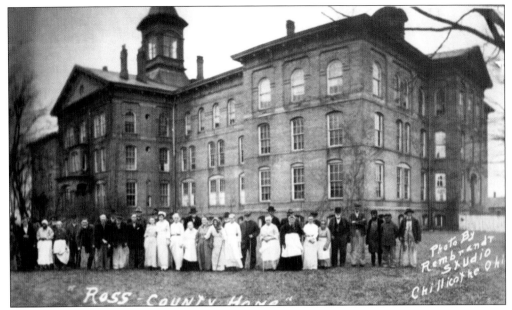

ROSS COUNTY INFIRMARY. The farm was purchased in 1850 on 347 acres of land. The main infirmary building was a four-story brick structure with a basement containing 98 rooms with 150 sleeping beds. The Ross County Infirmary was one of the largest infirmary buildings in the state and was generally well arranged for the separation and classification of inmates. (Courtesy of the Ross County Historical Society McKell Library.)

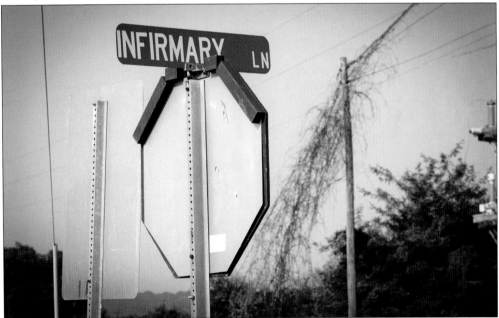

ROSS COUNTY INFIRMARY. According to the Ohio State Board of Charities 1883 annual report, the superintendent of the Ross County Infirmary "seemed dedicated to his work and is making efforts towards improved conditions at the infirmary." Unfortunately, the infirmary closed in the 1950s and was torn down in 1975. This street sign is located near the current Ross County Engineer's office. (Courtesy of Jeffrey Hall Photography.)

SCIOTO COUNTY INFIRMARY DEMOLITION. The first version of the Scioto County Infirmary was constructed in 1846 and destroyed by fire in 1882. Built on a 240-acre farm was a three-story brick building with a basement containing 26 rooms, with 7 of the rooms used by administration. The inmates have access to a kitchen, 2 dining rooms, 15 bedrooms with 32 beds, and 2 cells for the insane. (Courtesy of the Portsmouth Public Library.)

SCIOTO COUNTY INFIRMARY EARL THOMAS CONLEY PARK. Residents of the Scioto County Infirmary moved out of the building in 1965 when county commissioners decided to close the building. A sad 11 women and 6 men, with one woman a resident for more than 40 years, were sent to other local nursing homes. In 1975, the infirmary was demolished. Today, the site serves as the Earl Thomas Conley Park. (Courtesy of Jeffrey Hall Photography.)

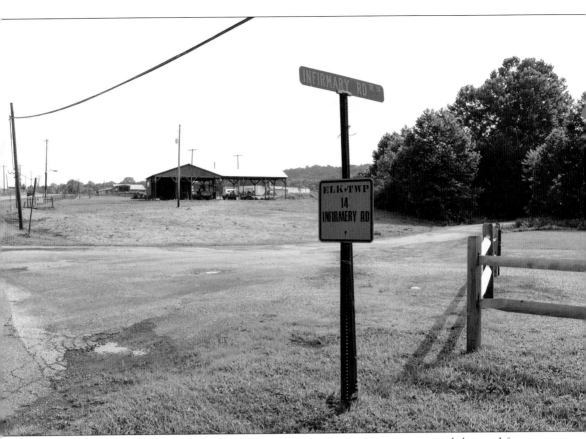

VINTON COUNTY INFIRMARY SITE. The Vinton County commissioners recognized the need for an infirmary and the construction of a new building was completed in 1874. The farm was 322 acres with 200 acres cultivated. The main building was a two-story brick with 41 rooms including a kitchen, a dining room, 2 sitting rooms, and 30 bedrooms with 30 beds. The superintendent used seven rooms, including a separate dining room and kitchen. Stoves heated the house; a good water supply was gathered from the well and cisterns, and moderate ventilation flowed throughout the building. Children were provided for in a separate building on the infirmary grounds. A two-story brick building with a large day room, the matron's room, sitting and dining rooms, and a kitchen with a room over the kitchen on the second floor for the sick containing two beds. Dormitory sleeping included five beds for girls and eight beds for boys. Closing in 1960, this building was razed. (Courtesy of Jeffrey Hall Photography.)

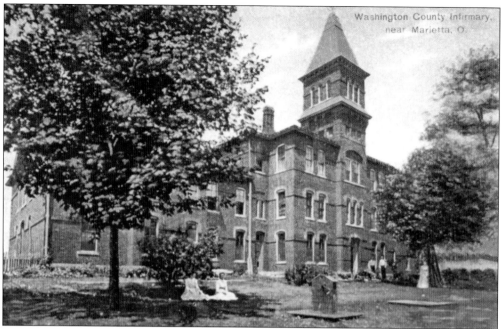

WASHINGTON COUNTY INFIRMARY. In 1838, the Washington County commissioners purchased 198 acres of farmland and constructed a home for the poor in 1840. The need for a larger and more-modern home was realized, and in 1883 a new county infirmary opened to local paupers. Additionally, more farmland was purchased expanding the site to 225 acres with 175 acres under cultivation. The new building was a three-story brick with 48 rooms with 8 used for administrative purposes. There was a separate dining room, kitchen, and four other rooms for the superintendent to use. Inmates were provided 20 bedrooms with 61 beds, a kitchen, and a dining room. The insane inmates occupied 12 cells. (Above, courtesy of Felicia Konrad-Bevard; below, courtesy of Washington County Commissioners.)

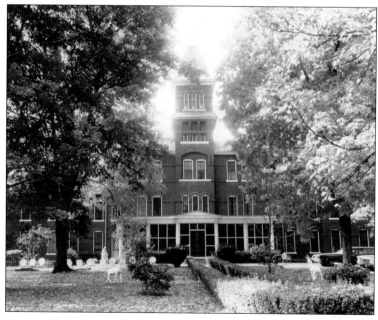

WASHINGTON COUNTY INFIRMARY SITE AND CEMETERY. The 1883 version of the Washington County Home was in operation until a new home was opened in 1976. Unlike most of the county homes still in operation, Washington County, with the help of a farm manager, continues to cultivate 265 acres of farmland and raise beef cattle and hogs for current county home residents to enjoy. There is also a garden where sweet corn, tomatoes, lettuce, cabbage, green beans, and onions are produced for the current kitchen staff to use when preparing meals for the residents. An orchard is also still in operation with 93 apple trees to produce pies, applesauce, cider, and apple butter. (Both, courtesy of Jeffrey Hall Photography.)

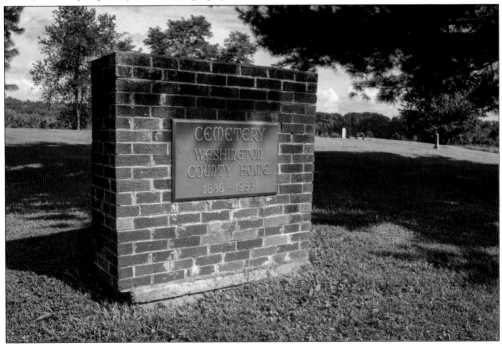

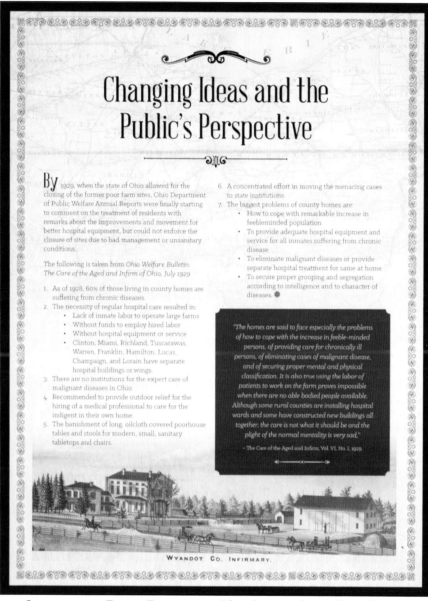

Changing Ideas and the Public's Perspective

By 1929, when the state of Ohio allowed for the closing of the former poor farm sites, Ohio Department of Public Welfare Annual Reports were finally starting to comment on the treatment of residents with remarks about the improvements and movement for better hospital equipment, but could not enforce the closure of sites due to bad management or unsanitary conditions.

The following is taken from *Ohio Welfare Bulletin: The Care of the Aged and Infirm of Ohio*, July 1929

1. As of 1928, 60% of those living in county homes are suffering from chronic diseases.
2. The necessity of regular hospital care resulted in:
 - Lack of inmate labor to operate large farms
 - Without funds to employ hired labor
 - Without hospital equipment or service
 - Clinton, Miami, Richland, Tuscarawas, Warren, Franklin, Hamilton, Lucas, Champaign, and Lorain have separate hospital buildings or wings.
3. There are no institutions for the expert care of malignant diseases in Ohio.
4. Recommended to provide outdoor relief for the hiring of a medical professional to care for the indigent in their own home.
5. The banishment of long, oilcloth covered poorhouse tables and stools for modern, small, sanitary tabletops and chairs.
6. A concentrated effort in moving the menacing cases to state institutions.
7. The biggest problems of county homes are:
 - How to cope with remarkable increase in feebleminded population
 - To provide adequate hospital equipment and service for all inmates suffering from chronic disease
 - To eliminate malignant diseases or provide separate hospital treatment for same at home
 - To secure proper grouping and segregation according to intelligence and to character of diseases. ❀

"The homes are said to face especially the problems of how to cope with the increase in feeble-minded persons, of providing care for chronically ill persons, of eliminating cases of malignant disease, and of securing proper mental and physical classification. It is also true using the labor of patients to work on the farm proves impossible when there are no able bodied people available. Although some rural counties are installing hospital wards and some have constructed new buildings all together, the care is not what it should be and the plight of the normal mentality is very sad."

– The Care of the Aged and Infirm, Vol. VI. No. I. 1929

WYANDOT CO. INFIRMARY.

CHANGING IDEAS AND THE PUBLIC PERSPECTIVE. The photographs of all the former poor farm sites, presented as both an exhibit and a book, serve as an example of the bureaucracy determined to implement the 19th-century practice of moral treatment or providing humane care for the worthy poor through the proper construction of county-funded housing. The use of documentary photography when telling the story of public charity, and its evolution over time helps the public audience better understand that a changing cultural landscape concerning a structure is omnipresent. Saving a building, donating an object, and the preservation of a document significantly enhance the understanding of what something meant to a previous generation. The distribution of charity is a story not always met with a positive mindset and is a largely forgotten aspect of our collective memory. That is why the use of documentary photography solidifies the significance of public charity at the inception of Ohio and efforts are continuously made to professionalize institutional care in modern times. (Photograph courtesy of Abby Bender and the Ohio History Connection.)

ABOUT THE ORGANIZATION

The Wood County Historical Society is a community organization that makes connections between the past, present, and future by capturing stories and cultivating memories of Wood County and the county home.

The institutional history of the Wood County Historical Society began in 1955 when the organization held its first meeting at the Wood County District Public Library. It was not until 1975 that the Wood County Historical Society set up operations inside the former Wood County Infirmary, which is now known as the Wood County Museum. The Historical Society has a 15-member board and two part-time employees.

The Wood County Board of County Commissioners is designated as the rightful owners of all museum buildings and grounds and is the appointing authority for all county-employed museum staff, which includes the director, curator, marketing coordinator, and education coordinator. The staff oversees the daily operations on behalf of the Wood County Historical Society, a nonprofit organization that is the appointing authority for the care of collections, installation of exhibits, marketing of programs and events, educational outreach, and facilitation of the county's tax appropriation dollars for repairs and improvements to the buildings and grounds.

The Wood County Museum is open daily. Admission charges do apply or become a member and enjoy free admission. Please visit the historical society's website at woodcountyhistory.org or follow on Facebook or Instagram at Wood County Museum.

DISCOVER THOUSANDS OF LOCAL HISTORY BOOKS FEATURING MILLIONS OF VINTAGE IMAGES

Arcadia Publishing, the leading local history publisher in the United States, is committed to making history accessible and meaningful through publishing books that celebrate and preserve the heritage of America's people and places.

Find more books like this at
www.arcadiapublishing.com

Search for your hometown history, your old stomping grounds, and even your favorite sports team.

Consistent with our mission to preserve history on a local level, this book was printed in South Carolina on American-made paper and manufactured entirely in the United States. Products carrying the accredited Forest Stewardship Council (FSC) label are printed on 100 percent FSC-certified paper.

MADE IN THE USA